DISCLAIMER

Publisher warrants that this book was prepared and published in good faith. However, the publisher makes no warrants, either expressed or implied, concerning but not limited to (1) the accuracy of the information contained in this book or (2) the use, purpose or results that may be obtained from the use of the information contained in the book. Publisher does not warrant or guarantee that the application of the information contained in the book is free from infringement of any copyright or patent held by any third party. The information or application of the information contained in this book is not intended for the use of young people or those persons who are inexperienced. Publisher's sole liability, if any, arising out of the application and use of the information contained in this book shall be limited solely to money damages not to exceed the sale price of this book. Any claim must be made in writing to the publisher within one year of the purchase of the book.

Supplies

PAINTS

Delta Ceramcoat® Acrylics and Delta Ceramcoat® Gleams™ were used for all projects in this book. Please refer to individual projects for their palettes.

BASIC SUPPLIES

Delta Ceramcoat® All-Purpose Sealer
Delta Ceramcoat® Pearl Luster™ Medium
Krylon® 7002 Satin Spray Varnish
Old stiff-bristled brushes for stippling, 3/8" angular and other shapes and sizes
Palette paper (appropriate for use with acrylics)
Paper towels
Sandpaper, fine-grit
Sea sponge
Soft cloths
Sponge roller
Stylus, optional (for transferring pattern lines)
Tack cloth
Tape (for securing traced patterns)
Tracing paper
Transfer paper, white

Water basin

Please refer to the individual projects for additional supplies.

BRUSHES

SILVER BRUSH LIMITED
Golden Natural™ Series 2000S Round: #2
Golden Natural Series 2005S Liner: #2, #4
Golden Natural Series 2006S Angular: 3/8", 1/2", 3/4"
Golden Natural Series 2007S Script Liner: #00
Golden Natural Series 2024S Grass Comb: 1/2"
Ruby Satin™ Series 2502S Bright (flat): #2, #4
Ruby Satin Series 2506S Angular: 3/8"
Silverstone™ White Bristle Series 1100S Round: #2, #4, #6, #8

SOURCE

Viking Woodcrafts, Inc.
1317 8th St. S.E.
Waseca, MN 56093
PH (800) 328-0116
http://www.vikingwoodcrafts.com

General Instructions

SURFACE PREPARATION

Sand the surface until very smooth, then wipe with a tack cloth to remove dust. Basecoat and seal the piece in one step using a sponge roller and a mix of Delta Ceramcoat All-Purpose Sealer + specified acrylic color (1:1). Let dry. Sand lightly again with fine-grit sandpaper, then clean the surface with a tack cloth. Should a second coat be required, use paint that is not mixed with sealer. Transfer the design.

TRANSFERRING PATTERNS

Trace the pattern onto tracing paper. You do not need to trace all the hair lines, but do trace lines for the basic shapes of objects or areas, such as markings on animals. Also trace details for eyes, ears, nose, mouth, and feet, and any other pattern lines you feel you need. Position your traced pattern on top of the wood piece, and secure it with tape. Slide white transfer paper under the pattern, coated side down, and lightly retrace the design using a stylus or ball-point pen.

FLOATING

Floating is a very simple and useful technique. It can be used to apply shadows or highlights on an area. Use angular brushes for floating unless instructions specify another type. Dip a clean brush into water and then blot on a paper towel to remove excess water. Sideload the brush by dipping or stroking the long corner into the paint, and then stroke on the palette paper until you have a smooth transition of color across the brush, from strong color on the loaded side to clear water on the opposite side. Now you are ready to float color on the desired area.

BACK-TO-BACK FLOATING

This technique is used when a highlight is placed away from the edges of an object or area (such as highlights on the glass marmalade jar in the "Breakfast" project). Sideload the angular brush with White (refer to "Floating" for sideloading instructions), and place the loaded side next to the center of the highlight area. Pull the stroke from the top to the bottom of the area. Turn the brush over so the loaded side is again toward the center of the highlight area, and float paint against the back of the previous stroke, so that the paint side of both strokes touch, back-to-back, without a gap between them. The highlight will be strongest in the center, with the color fading toward the sides.

BLENDING

Blending is a very old technique, which became widely used during the Renaissance with the advent of oil paints. Among others, Leonardo da Vinci used this technique in his paintings whenever he needed to move from a darker to a lighter color value.

When I use this technique with acrylic paints, I always work wet-on-wet. Working quickly so that the paint does not dry, I start by placing a small quantity of each of the color values to be blended side by side and then, using a flat or angular brush and short criss-

(Continued on Page 4)

General Instructions
(Continued from Page 3)

cross (slip-slap strokes), I blend the colors together where they meet. If your paint dries quickly, you may need to doubleload a brush with both colors to be blended, apply the paints where the two colors meet, and then continue to blend.

If there are any brush marks left after I'm finished blending, then I use a soft, dry brush or mop brush to erase them. Sometimes, three color values are used for the transition: dark, medium, and light.

DRYBRUSHING

Use the drybrush technique to achieve dimension and contour. This is done by depositing the greatest amount of paint in the center of an area and then stroking the excess toward the edges. Also use this technique to gradually intensify the dark colors in the shadow areas. Always allow the surface to dry between layers.

I use a dry, round bristle brush (Silverstone Series 1100) to drybrush color(s) on specified areas. In smaller areas, I often drybrush with a Ruby Satin flat brush. After loading the brush, rub it on the palette to remove excess paint and work it into the brush bristles. Hold the brush at a 45-degree angle and apply paint.

With each stroke, there will be less and less paint in the brush, allowing more and more of the background to show and the edges to remain darker. This technique helps to create the illusion that edges bend and objects are rounded. You may need to do this more than once to get the coverage you want.

STIPPLING

Stippling is often used to create the illusion of texture, such as on the rolls in the "At the Bakery" project. It's also used to create foliage on branches and trees. I usually use an old, stiff-bristled brush for stippling. An old 3/8" angular brush is often used to stipple foliage, while other sizes and shapes are used to stipple other textured areas.

Begin by loading the brush with a small amount of paint, and then remove excess paint by pouncing it on a paper towel. To stipple, hold the brush vertically and pounce the bristles up and down on the painting surface. Allow the background color to show through. This technique can be applied wet-on-wet or wet-on-dry. It is helpful to practice the pouncing motion on the palette paper before applying to the painting surface.

To achieve dimension and depth, begin with the darkest colors and gradually change to the lighter ones, allowing each layer to dry before applying the next (unless instructed to apply wet-on-wet). After the darkest layer has been applied, it is sometimes convenient to load the brush with two different colors to stipple both middle and light values at once. For example, you may want to load the angular brush with a medium-value green and then pick up a small amount of a highlight color (yellow or white, perhaps) on long corner of the brush.

To produce foliage of different shapes and sizes, vary the pressure on the brush and turn it often as you pounce, keeping the long corner of the brush pointing outward to form the foliage on the tips of the branches.

WASHES

Washes give a painting realism and help to integrate all elements. Many painters bring uniformity to their pictures by selecting a neutral color from the palette and adding it to each of the other colors used in a project. I prefer to reach that uniformity with sheer, evenly-applied washes of a specific color. This step is very important for achieving a pleasing end result.

The way to apply a wash is simple. Be sure to use flat or angular brushes that are in good condition. Mix a wash on the palette, using a small amount of paint and enough water to make the color very transparent, which is important to achieve quality and richness in the finished project. Before loading, check to make sure that no residue of paint from a previous load remains in the brush. I typically use a soft 3/8" angular brush, but also use other brushes depending on the size of the area. Apply the wash smoothly and evenly—generally to an entire area. Occasionally, however, washes are applied on small portions of a design element, such as the iris of an eye.

PAINTING GRASSES

Grasses are painted with a doubleloaded liner brush. Thin the darker grass color to ink-like consistency and fully load the brush; then, pick up the full-strength lighter color (usually White) on one side of the brush. As you pull a stroke, the two colors should still be visible, yet slightly blended, on each blade of grass.

PAINTING PROCEDURE FOR ANIMALS

Always refer to the step-by-step color worksheet illustrations when painting the animals. Several techniques are used in the layering process for painting animals; these include drybrushing (when instructed), painting hair, and applying washes. Water is the only medium used to dilute the paint.

NOTE: Always allow each layer of paint to dry completely before applying another layer, except when painting wet-on-wet.

I generally start with a dark background basecoat color (Black is used for almost all of the projects in this book), and then achieve shape and depth in the design by layering lighter colors. The black background provides deep shading where it shows through the lighter layers and also serves as the basecoat for the areas that will remain black.

Before you begin painting the design, it is important to refer to the color photo to study the different dark zones on the body and head of an animal (the area around the eyes, the nose, mouth, inner ear, and markings such as spots and stripes).

STEP 1: HAIR

"Hair" or "fur" is developed by alternating layers of hair strokes and transparent washes, generally repeating the layers four or more times. When layering, White paint is used for the hair, and then washes are applied, starting with the darkest color and ending with the lightest.

When applying the first layer of hair, use a comb or liner brush for shorter hair; use a 3/8" angular brush for longer hair. Use a liner brush for succeeding layers of hair. Using thinned White, start the first layer of hair strokes near the outer edge of an area and pull the strokes outward. As you work inward (toward the center area of the face if painting the head, for example), overlap strokes to hide where previous strokes began. For long hair, apply the strokes in a waving motion (practice this stroke on the palette first). Allow to dry. Using the darkest color listed, apply the first wash, making sure that the application is very smooth, and allow to dry again. Apply the second layer of hair more sparsely than the first layer, and then apply the next wash (lighter color than the first). Continue layering in this manner until the volume of hair is as you wish.

STEP 2: HIGHLIGHTS AND SHADOWS

When painting animals, it is important to place the shadows and highlights in the hair according to the direction of the light source. Define and enhance some of the short hairs by using White to add bright highlights. Gradually deepen the shadowed areas by using a 3/8" angular brush to float medium and dark values of the colors used in those areas. Finally, add a few Black hair strokes in the

shadow areas, and enhance the brightest highlight areas with White strokes.

STEP 3: FINAL TOUCHES

After the layering process has been completed, darker colors can be used for adding detail and contrasting hair, and White can be used to add the bright hairs to the lightest areas of the fur.

FINISHING

Allow the paint to dry completely and then varnish with Krylon Satin Varnish. With the painted piece lying flat, follow the directions on the label and spray several light coats to achieve a smooth finish. Allow each coat to dry completely, lightly sand, and wipe off the sanding the dust before applying the next.

Coffee Time
Color Photos on Front Cover & Page 2

PALETTE
DELTA CERAMCOAT ACRYLICS

AC Flesh	Light Sage
Avalon Blue	Maroon
Bittersweet Orange	Midnight Blue
Black	Mocha Brown
Bright Red	Mudstone
Brown Velvet	Palomino Tan
Burnt Sienna	Pink Angel
Caribbean Blue	Red Iron Oxide
Dark Brown	Straw
Dark Chocolate	Tangerine
Dark Goldenrod	Tide Pool Blue
Georgia Clay	Vintage Wine
Golden Brown	White
Ivory	

SPECIAL SUPPLIES

Delta Ceramcoat Antiquing Gel, Brown
MDF or Masonite panel (approximately 23" x 16")
Wooden frame with small shelf and drawer

PREPARATION

Please refer to the "Surface Preparation" section at the front of the book.

FRAME: Use a 3/4" angular brush to apply two coats of Straw, slightly thinned with water, to the frame. When dry, create an aged look by applying antiquing gel over the entire surface; remove excess with a soft cloth

PANEL: Basecoat the panel with Black + sealer (1:1). When dry, transfer the design.

PAINTING INSTRUCTIONS

Please carefully study the step-by-step color worksheet before starting.

BACKGROUND

Step 1: The wood paneling in the background is developed using a wet-on-wet technique. To create this paneling, doubleload a 3/4" angular brush with Ivory and Burnt Sienna and, using the chisel edge of the brush, apply vertical strokes to form wood grain. Continuing to work wet-on-wet, doubleload the brush with Georgia Clay and Red Iron Oxide; apply vertical strokes here and there to give your wood background a variegated appearance. Let dry.

Using a #00 liner brush with Black, paint fine division lines to define the panels. Float Dark Brown down both sides of each line using a 1/2" angular brush, and let dry. As a final step, use the same brush to apply a Dark Goldenrod wash to the surface, and allow to dry again.

Step 2: The floor area is developed using the stippling technique and an old stiff-bristled brush. Load your brush with Straw and stipple the entire floor area, always holding the brush perpendicular to the surface, with the chisel edge parallel to the bottom edge. Allow some of the black background to show through the stippling to create some shadows, which will help you obtain a carpet texture for the floor. Once dry, unify the area by applying a Straw wash, and allow to dry again.

Using a #6 round bristle brush with Vintage Wine, drybrush the shadow areas, corners, and cast shadows. If necessary, drybrush a little Straw here and there to complete the carpet.

COFFEE JAR AND LABEL

Figure A1: Paint the coffee inside the jar using a 3/8" angular brush with Brown Velvet, blending with Burnt Sienna towards the center of each area. Using the same brush, undercoat the lid with White, allow to dry, and then basecoat lid with Bright Red.

Paint the letters on the coffee label using a #2 round synthetic brush with White and Bright Red. Using Bright Red, paint the red label areas around the letters, and allow to dry. Paint the small center portion of the label (behind the red letters) with White. Continuing with the same brush, paint the yellow label background around the letters, starting with Straw at the bottom and blending towards the top with Mocha Brown. When dry, use a #00 liner brush and Black to outline the red and lower white letters. Finish the lower-right red patch on label with Black, painting the letters and outlining the upper-right edge.

On the label, paint the coffee cup and saucer using a #4 flat brush with White, blending with Tide Pool Blue towards the shadow area on the saucer. Use a #2 round synthetic brush with Ivory to paint the coffee in the cup. Add Golden Brown dots for the foam and use Dark Chocolate for the small dark area.

Use a #2 round synthetic brush with Burnt Sienna to paint the coffee beans on the label. Outline the beans with Black using a #00 liner brush.

Figure A2: Apply a wash to the coffee in the cup with Mocha Brown, using a 3/8" angular brush. Highlight the foam with Ivory and a #00 liner.

Using a #00 liner brush with White, paint two curved lines of light on the top of the lid. Then use a 3/8" angular brush to float Burnt Sienna down the left side and along the top, curved edge of the front edge of the lid.

Using a 3/8" angular brush, float White all the way around the contour of the jar. Use the same brush and color, paint inner shines along the curved areas, down both sides, and on the bottom. With a #00 liner brush and White, reinforce highlights on the curved shines, especially those on the upper-right and lower-left.

(Continued on Page 10)

Coffee Time

Instructions on
Pages 5 & 10-11

Match and attach with
the pattern section on
pages 8-9

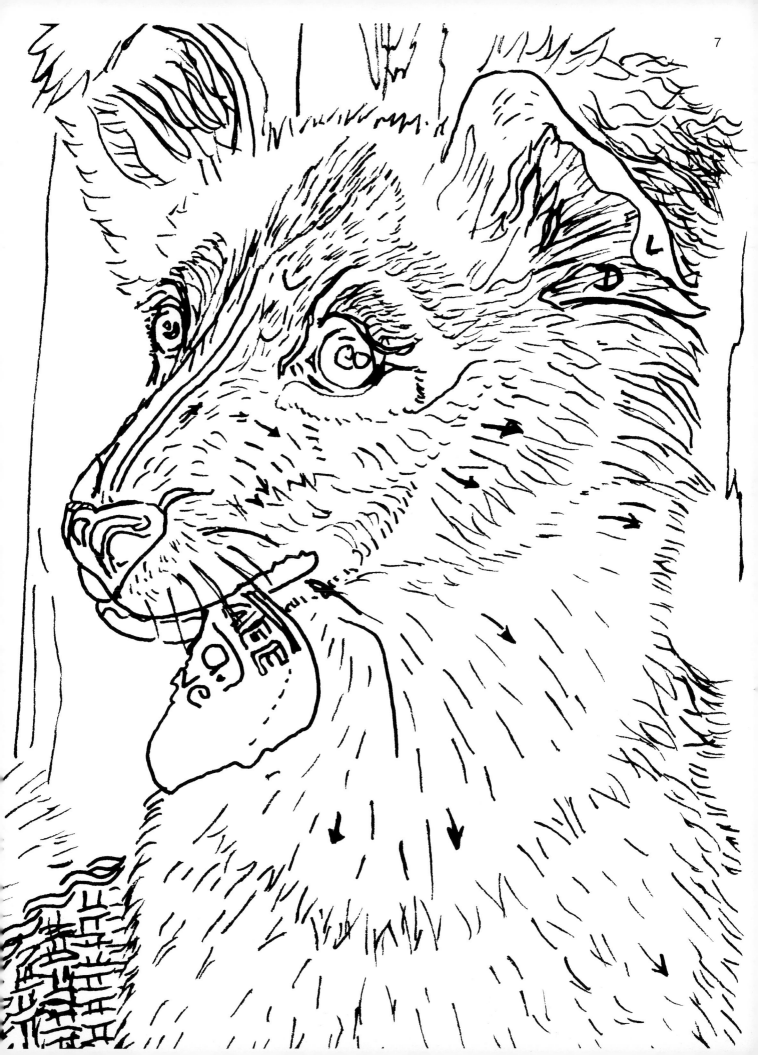

Coffee Time

Instructions on Pages 5 & 10-11

*Match and attach with the pattern
section on pages 6-7*

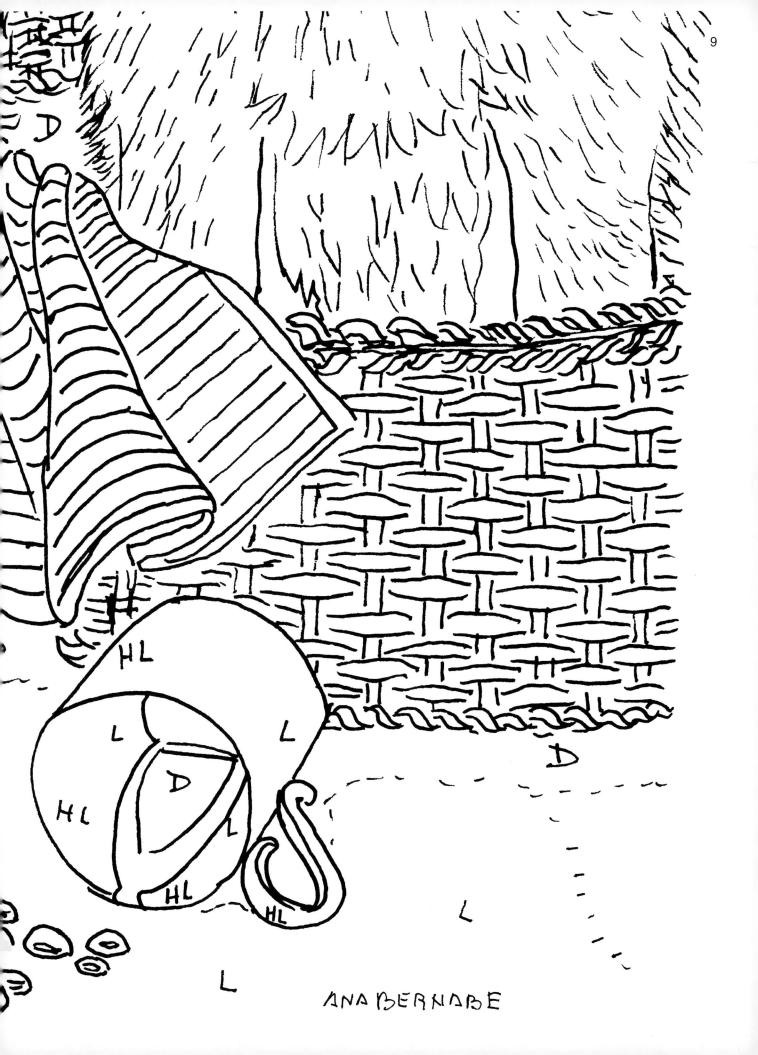

10

Coffee Time
(Continued from Page 5)

Paint the area where the label was torn from the jar using a #2 round synthetic brush with very thin White. Let dry, and then apply a Mocha Brown wash using 3/8" angular brush. Use the same brush and Straw to paint the torn label in the collie's mouth, blending towards the top right with Mocha Brown. With a #2 round synthetic brush, paint the letters with White and Bright Red, and allow to dry. Continuing with same colors and brush, paint background around letters.

COFFEE CUP

Figure A1: Use a 3/8" angular brush with Tide Pool Blue to basecoat the inside of the cup around the coffee. Clean the brush, and basecoat the bottom (inside the cup) with AC Flesh. Inside the cup, use a #2 round synthetic brush to paint a White stripe around the contour of the coffee. Within the white stripe, paint the coffee with Dark Chocolate, allowing a smaller Black spot to remain in the center.

Undercoat the outside of the cup using a 3/8" angular brush with White, and allow to dry. Now, basecoat with AC Flesh using the same brush. Use a #2 round synthetic brush with AC Flesh to paint the shaded area of the handle.

Figure A2: Using a 3/8" angular brush, apply a Bittersweet Orange + Maroon (1:2) wash to the coffee area inside the cup, and let dry. Deepen the dark area in the center of the coffee using a #4 flat brush with a touch of Dark Chocolate. With the same brush, apply a smaller spot of Black in the center.

Using a 3/8" angular brush with White, float along the inner rim of the cup and around the coffee spill. Also float along the outside edges of the cup. Let dry.

With a #4 round bristle brush, drybrush the outside of the cup with White, starting on the left side and moving towards the right, softly fading the color so it does not completely cover the basecoat. Similarly, use the same brush to drybrush on the inside of the cup, starting from the White areas and fading into the basecoat color, thus obtaining a gradual passage from light to shadow.

As a last step, use a #00 liner brush with White to paint a fine, ragged line where the base of the coffee meets the bottom of the cup.

SPILLED COFFEE DROPS

Basecoat the coffee drops using a #4 flat brush with Dark Chocolate, blending towards their centers with either Burnt Sienna (for lighter drops) or Black (for darker drops). With a #00 liner brush, paint a Black line along the base of each drop.

The way you paint the highlights is very important in order to give the drops a three-dimensional look. Using a #00 liner brush with White, paint a fine line near the base of each drop, following its curvature (as is clearly seen in the largest drop). Then reinforce the White in those areas of greater light—where the curvature is more prominent.

BASKET

Figure A1: Paint the braided edges with a #4 liner brush and AC Flesh, applying S-shaped strokes, one beside the other. Continuing with the same brush and color, paint the vertical ribs, and then define the wickerwork by painting straight strokes over alternating ribs in each row.

Figure A2: Using a #4 flat brush with Mocha Brown, shade the ends of each horizontal wicker segment. With Burnt Sienna, deepen some of the shading where the wicker goes under the rib.

Use a #4 liner brush with Ivory to softly highlight the center of each segment and strokes on braided edges, and let dry. Then apply a Dark Goldenrod wash over the entire surface with a 1/2" angular brush. Drybrush Dark Brown with a #4 round bristle brush to define the dark shadows above the napkin inside the basket, lightly behind the coffee cup and napkin, and at the right side of basket. When dry, lightly wash the lighter shadow areas with Mocha Brown.

NAPKIN

Figure A1: Undercoat the entire napkin with White, and allow to dry. Transfer lines and fold detail. Basecoat stripes and edges with a #2 round synthetic brush and Bright Red.

Figure A2: With a 1/2" angular brush, float Burnt Sienna along the napkin folds, separating them and adding dimension to the cloth. Let dry, and then deepen some of the shadows along the folds with Dark Brown.

CAT

Figure A3: The cat is very simple to paint. Dilute Tide Pool Blue to the consistency of ink, and then load a 1/2" grass comb brush halfway up the bristles; press the brush against your palette to separate the bristles before painting. Paint the first layer of hair on the body, leg, bridge of nose, and below the right ear.

Use a #4 liner brush with Palomino Tan to paint hair above the left eyebrow and behind the ears. Use same brush and color to shade the areas on both sides above the nose, and on a small area to the left and behind the muzzle. Continuing with Palomino Tan, use a #00 liner brush to paint lines that define the shadow areas below the eyes, above the muzzle, left side of face, and to separate the paw from the leg.

Use a #4 flat brush with Pink Angel to paint inside of ears, blending with Georgia Clay towards their centers. With the #4 liner brush and White, paint the following areas: stripe along the center of the forehead; top of the head; muzzle; nose; upper and lower eyelids; left side of face; edges of ears; and tuft inside right ear.

Figure A4: Use a #00 liner brush to paint long White hairs on the body, making them more dense towards the center. Paint the leg in the same way, remembering that it has shorter and denser hair than the body.

Using a #4 Ruby Satin flat brush with White, drybrush each toe to add volume, being careful not to paint over the separations between toes. With a #2 round bristle brush, drybrush a very small Dark Brown shadow on the inner curve of the leg, where it meets the body. Also drybrush two very small shadows on the lower portion of the face to define the cheeks.

With a clean brush and Golden Brown, paint the soft shadows just above the toes to help define the paw. Paint the claws using a #00 liner brush with Burnt Sienna. With the same brush, paint short White hairs around the toes and over the darker shading above the toes.

Paint White hairs all over the face integrating the colors defined in Figure A3 and brightening the area over the nose. Softly drybrush Dark Brown to define facial features, the tear ducts, and on the right of the forehead. Drybrush below cheeks with same color, applying more firmly. Use White to shape the eyelids, and to paint hairs on the left side of the face and inside the ear.

Clean your brush and add slight shading by painting some Golden Brown hairs below the left ear; also add some to the hairs on the right side of the face and on the top edges of the ears. With thinned Black, paint a few very short and fine hairs around the inner edges of the ears, in the shadow area below the left eye, and

at the lower edges of the forehead (at the base of the long eyebrow hairs). Add just a few longer hairs in the ears.

Use a #2 round bristle brush with Mudstone to drybrush touches of color and soft shading on the lower eyelids, tuft of hair behind left cheek, sides of nose, top of right eyelid, and below right ear. Use the same brush and color to softly shade the right side of face in order to separate it from the body.

MUZZLE: Use a #00 script liner brush to add White hairs to this area. With the same brush, paint thin White and Black lines side by side (touching) for each whisker and eyebrow hair. Use a #2 round synthetic brush with Pink Angel to paint the nose; highlight around and between the nostrils with a touch of White. Then use a #00 liner brush and Black to lightly add small dots at the base of the whiskers, and to define the mouth and contours of the nose.

EYES: Basecoat each iris with Caribbean Blue using a #2 round synthetic brush, blending with Light Sage towards the center. Once dry, use the same brush to apply a few dots to the top of the iris with diluted Avalon Blue. Use a #00 liner brush to enhance the right side of each pupil with Light Sage, and allow to dry. Apply a light Golden Brown wash over the irises and lower portion of pupils with a #2 round synthetic brush. With a #2 round bristle brush, lightly drybrush Black across the top of each eye.

Using a #00 liner brush, paint White shine marks; then, as necessary, outline the eyes with Black to clean up their edges. Use the same brush to define the inner borders of the eyelids with Burnt Sienna.

DOG

Figure A3: Paint a first layer of hairs on the body with Tide Pool Blue, using a #4 liner brush. Start the first layer of strokes near the lower portion of the body and work your way upwards, slightly overlapping the strokes of the previous row/layer in order to hide the base of the individual hairs or tufts.

Figure A3 shows the placement of colors on the face of the dog. Use a #4 liner brush to paint Tangerine hairs from the both sides of the nose all the way up to the forehead, on the inside of the ears, left-upper eyelid, and along all facial lines (division lines between different hair colors) on the right side of the face. Paint the lighter layers of hair using the same brush with Palomino Tan; then use White to paint the muzzle and the fringe along the brows and forehead. (You may want to reapply hairs here and there, layering Tangerine and Palomino Tan hairs until the desired affect is achieved.)

Drybrush the nose with White using a #4 Ruby Satin flat brush; then use a round brush with Black to add shape to the nostrils and mouth. Once dry, use a liner brush and White to add a few dots to the top of the nose for a bit of extra shine.

Paint the irises with Burnt Sienna using a #2 round synthetic brush. Paint the whites of the right eye with White.

Figure A4: Use a #00 liner brush with White to apply hairs over the face, without totally covering the underlying colors, and then let dry. With a 1/2" angular brush, apply a Golden Brown wash over all parts of the face with the exception of the muzzle and the white fringe on the forehead. Let dry.

Use a #00 liner brush with Mocha Brown to paint hairs on the shaded areas of the face, and let dry. With the same brush, paint Georgia Clay hairs over the Tangerine areas without covering them completely. Paint an extra layer of hair with White to brighten the mouth area and to define a small white tuft inside the right ear.

Continue using the liner brush to paint Black hair in the following areas: in the ears, around the contour of the head, the lines that run from the nose to the forehead, tops of ears, and the whiskers.

Also paint Black hairs starting from the markings around the eyes and slightly overlapping the lighter surrounding areas.

Using White, define tufts of hair on the body with a #4 liner brush. Continue working with a #00 liner brush, adding shape to the ends of each tuft. Paint denser tufts in the lighter areas. Use the same brush with Georgia Clay to paint some hairs on both sides of the lower body.

Shade the angle between the left leg and the basket with Dark Brown, using a #4 flat brush. Use a 1/2" angular brush to float Midnight Blue on body next to right leg. Use the same color and a #00 liner brush to define some shaded tufts on the lower half of the chest.

Using a 1/2" angular brush, apply a Golden Brown wash over shaded areas such as under the neck, sides of body, and lower half of chest.

Using a #00 liner brush with White, paint the eye shines as curved parallel vertical spots, and then add a small dot near the center of the eye. On the right eye, along the top of the iris, add an additional, soft shine with White using a #2 round synthetic brush. Allow to dry, and then lightly wash this soft shine with Midnight Blue. Loosely outline the inner eyelids with Tide Pool Blue.

FINISHING

Refer to the "Finishing" section in the "General Instructions" section at the front of the book.

Pattern on Pages 6-9

At the Bakery

Color Photo on Page 16

PALETTE
DELTA CERAMCOAT ACRYLICS

AC Flesh	Maple Sugar Tan
Bambi Brown	Mocha Brown
Black	Old Parchment
Bridgeport Grey	Opaque Yellow
Burnt Sienna	Payne's Grey
Cape Cod Blue	Pink Angel
Dark Brown	Purple Smoke
Dark Goldenrod	Red Iron Oxide
Georgia Clay	Straw
Golden Brown	Wedgwood Blue
Ivory	White
Light Ivory	Yellow

SPECIAL SUPPLIES

Carved wooden frame (overall dimensions approximately 18" x 23")
Delta Ceramcoat Antiquing Gel, Brown
Delta Ceramcoat Pearl Luster Medium
MDF panel (approximately 11" x 16")
Old, stiff-bristled brush (for stippling)
Paper lace cake doilies (approximately 4" in diameter)
Stencil brush or small sponge

PREPARATION

Please refer to the "Surface Preparation" section at the front of the book.

FRAME: Use a 3/4" angular brush to apply diluted White to the frame. Let dry, and clean your brush. Apply Pearl Luster Medium with the same brush. When dry, apply antiquing gel over the carved corners, and softly remove the excess with a cloth to bring out the carved relief of the frame. If necessary, highlight the areas of high relief with Pearl Luster Medium, and let dry.

PANEL: Basecoat the panel with Black + sealer (1:1). Let dry, and then transfer the design.

PAINTING INSTRUCTIONS

Please refer to step-by-step figures B1 through B8 on the color worksheet to better understand the instructions.

COPPER MILK CANS

NOTE: Refer to the markings on the line drawing to determine dark (D), light (L), and highlight (HL) areas.

Step 1: (Figure B1) Using a 1/2" angular brush with White, paint stripes on the vertical surface and curved shoulder of the left can. Continuing with White, use a #2 round brush to paint the wire portion of the handles, and fine lines along the wood handgrips of both cans to form the wood grain. Let dry.

Step 2: (Figure B1) Apply a Burnt Sienna wash to the left can and both wooden handles using a 1/2" angular brush, and let dry.

On the right can, use a 1/2" angular brush with White to define the shape of the reflections, marked "L" on the line drawing. These reflections are interrupted by the shoulder of the can and continue onto the neck; be sure to separate the painted reflections between the neck and the shoulder so that they do not appear as a straight line. Paint the curved shoulder with White, always following along the transferred lines.

Paint the egg reflections on both cans with a #2 round synthetic brush and White. Please refer to figures B3 and B4 of the color worksheet to paint these reflections, using the colors and instructions given for painting eggs later in this project.

Refer to those areas marked "D" on the line drawing of the right can. Use a #4 flat brush to apply a coat of Purple Smoke down the left side and bottom, to paint the curved reflection from the left can, and a dark stripe on the neck. Use a 1/2" angular brush to apply a Purple Smoke wash over the lighter reflection areas on the left side of the can. Let dry, and clean your brush. Finally, apply a Burnt Sienna wash to the rest of the can.

Step 3: (Figure B2) On the left can, use a #4 flat brush with White to drybrush highlights along the curved shoulder on the top and down the central area of light (marked "HL" on the line drawing). Use a 1/2" angular brush with Payne's Grey to float two vertical lines down the left side of the can, placing the loaded brush edge towards the left edge of the can and floating downwards. Continuing with Payne's Grey, also float shading above and below the handle, along the curved reflection of the wooden handle (right above the handle), the edges of both handles, and the curved reflections of the ladle. Let dry. On the left can, randomly drybrush Georgia Clay using a #4 round bristle brush to add extra touches of color to its metallic surface.

Use a #4 liner brush with Cape Cod Blue to paint the wire handles and shadows projected by the handles' wires. Use a #4 liner brush with White to highlight the wires and the areas of insertion into the handles.

Use a #2 round bristle brush with White to drybrush highlights along the central area ("L") and ends of each handle; then apply a Golden Brown wash to entire handles. Let dry. Use a #00 liner brush and Georgia Clay to paint fine lines along handles, imitating wood grain.

Step 4: (Refer to the color photograph.) On the right can, use a #4 round bristle brush with Georgia Clay to drybrush touches of color down the center of the can, on the curved shoulder area, and neck. Do not cover completely. With a clean brush, add Opaque Yellow touches to the lighter area of the shoulder. Using a 1/2" angular brush, float Purple Smoke shadows above and below the shoulder, between the handle's wires. With a #2 round bristle brush, drybrush Red Iron Oxide on the lower-left area to form the reflection of a loaf of bread.

Using a #2 round synthetic brush with diluted White, highlight the reflected area on the right can that appears above and below the handle's projected shadow (top left of can, marked "HL" on the line drawing). Clean your brush, and then apply a Wedgwood Blue wash over the white highlight, dragging the color towards the brownish area to the right. Using Cape Cod Blue, paint the handle's shadow, and then add some touches to the lower-left edge of the can.

LADLES

Step 1: Use a #2 round bristle brush with Purple Smoke to softly drybrush the inside of both ladles, without completely covering the black basecoat. Also drybrush along edges and center of handles, and the rims.

Step 2: Continuing with the bristle brush, drybrush Burnt Sienna to add rusty areas to the inside of the upper ladle and to add a V-shape on the outer edge to simulate a spot of rust. Lighten

the rust spot within the ladle by drybrushing its center with Mocha Brown. Continue drybrushing Mocha Brown on the far ends of the handles. As a final detail, use a #00 liner brush and Black to paint a fine line down the center of the V-shape to imitate a small crack.

WHEAT

Shape the seeds using a #2 round synthetic brush and White, applying a thicker coat of paint in the center of each seed. To form the slight teardrop-shape of these seeds, paint a thin filament from each seed using a #00 liner brush with White. Let dry.

With a 1/2" angular brush, apply a Yellow wash to the entire area, and allow to dry. Using a #2 round bristle brush, drybrush a touch of Georgia Clay on the base of each seed. Paint the center shaft using a #00 liner brush with Maple Sugar Tan. Float the background behind the sheaf of wheat with a 1/2" angular brush and Mocha Brown.

FLOUR

Apply a coat of Cape Cod Blue to this area, and allow to dry. Stipple White over the area with an old, stiff-bristled brush, let dry, and then use a #2 round synthetic brush with White to slightly define the irregular shapes left by the stippling and to add relief to the lumps in the flour.

EGGS

Refer to figures B3 and B4 to paint the eggs.

Step 1: Use a #4 flat brush to define a three-shade color map. Begin by painting an AC Flesh round spot in the center of the egg, then paint a Golden Brown area around it, and, finally, apply Bambi Brown in the remaining area. Paint a thin sliver of AC Flesh on the bottom of the egg, where light is reflected. Let dry.

Step 2: Use a #4 round bristle brush and Old Parchment to integrate the different shades of the color map by drybrushing from the center of the spot towards the edges. Apply a heavier coat in this center area and fade towards the edge where the coat should be thin and almost translucent. Drybrush a Light Ivory highlight area starting from the center of the spot and extending only halfway to the edge. Use a #00 liner brush and Light Ivory to define the thin highlight line at the bottom of each egg.

TABLES

Using a 1/2" angular brush with Burnt Sienna, paint the tops of both the table under the bread and the one under the ladles. Using the same brush, paint the edges with Dark Brown.

DALMATIAN PUPPY

Please refer to figures B7 and B8 on the color worksheet.

Step 1: Paint all transferred lines with a #00 liner brush using Pink Angel. Let dry, and then apply a layer of White hair, taking care not to cover the black spot areas. Using a #4 Ruby Satin flat brush with Burnt Sienna, drybrush around the spots on the body, nose, mouth, and left ear. Apply a Wedgwood Blue wash over the entire puppy with a 1/2" angular brush, and let dry.

Step 2: With a #00 liner brush and White, paint a second layer of hair, applying a denser layer to the lighter areas. Use a #2 round bristle brush with Pink Angel to drybrush along the folds on the right side of the puppy's body, the folds on the face, and between the toes. Then, use a #00 liner brush to paint White hairs slightly overlapping the spots. Remember to always follow the direction of hair growth. Paint a few Burnt Sienna hairs on the muzzle and toes.

Step 3: Use a #2 round synthetic brush with Burnt Sienna to basecoat the irises of both eyes, and allow to dry. Float Dark Goldenrod along the bottom of each eye, allowing it to fade into the basecoat. (The iris of the puppy's right eye is just barely visible.) With White and a #00 liner brush, paint the small inner corner of

the eyes, and add a small highlight dot to the pupils. With the same brush and color, add small shine dots to the nose and paint small, curved lines to define the nostrils.

Loosely paint the floor under the puppy using 1/2" angular brush and Burnt Sienna; working wet-on-wet, slip-slap Black below the tablecloth, loosely blending it into the area.

LACE TABLECLOTH

This tablecloth looks very difficult but it is actually very simple to paint. Use paper lace cake doilies as stencil templates. These come in different designs, so you can choose one to your liking.

Place the doilies over the tablecloth area. Apply White paint over the doilies using a stencil brush or small sponge; use Mocha Brown when painting over the dalmatian. Remove each doily and you will see a negative of the doily. You will probably need to reinforce some of the lines, perhaps adding a simple border. Let dry.

Using a 1/2" angular brush, apply a Golden Brown wash over the tablecloth, being careful not to cover the puppy, and let dry. Add a bit of texture to the lace design by painting White highlights and Black shadows here and there using a #00 liner brush.

Use a 1/2" angular brush and Burnt Sienna to float shading where the tablecloth drops over the edge of the table.

LOAVES OF BREAD

Please refer to figures B5 and B6. The instructions should be repeated for each individual loaf of bread.

Step 1: Using a 1/2" angular brush, basecoat with AC Flesh, and allow to dry. Using a #4 round bristle brush, drybrush the crust area with Straw.

Step 2: Stipple the soft part of the bread using an old stiff-bristled brush and White. Let dry.

Using a #4 round bristle brush, continue to drybrush the crust area, always fading and blending colors into each other. Begin by drybrushing down the sides with Georgia Clay; then load the brush with Red Iron Oxide and deepen the shadow areas. Clean and dry the brush, and then use Ivory to add highlights to the lighter areas of the crust. Once dry, use a 1/2" angular brush to apply a Dark Goldenrod wash to the crust. Finally, use a #00 liner brush with Burnt Sienna or Dark Brown to paint fine uneven lines and small cracks along the edges of the crust.

BEATER

As needed, transfer details and touch up gear shape with Black. Use a #4 liner brush with Bridgeport Grey to paint all transferred lines. Refer to the color photo for placement of highlights and shadows, and then use the same brush with White to add random highlights. Let dry. With a #4 Ruby Satin flat brush and Cape Cod Blue, drybrush shadows on areas of the gear, such as where each tooth is highlighted on one side and shaded on the other.

Basecoat the wooden handle with White, and let dry. Using a #4 flat brush, paint the handle again. Start with Straw near the front and pick up Mocha Brown as you move towards the back, blending the two colors. Using a 3/8" angular brush, lightly wash Mocha Brown on the gear, just above the handle. Using White and a #2 round brush, reinforce highlights in the foreground and the shine of the central screw.

FINISHING

Refer to the "Finishing" section in the "General Instructions" at the front of the book.

Pattern on Pages 14-15

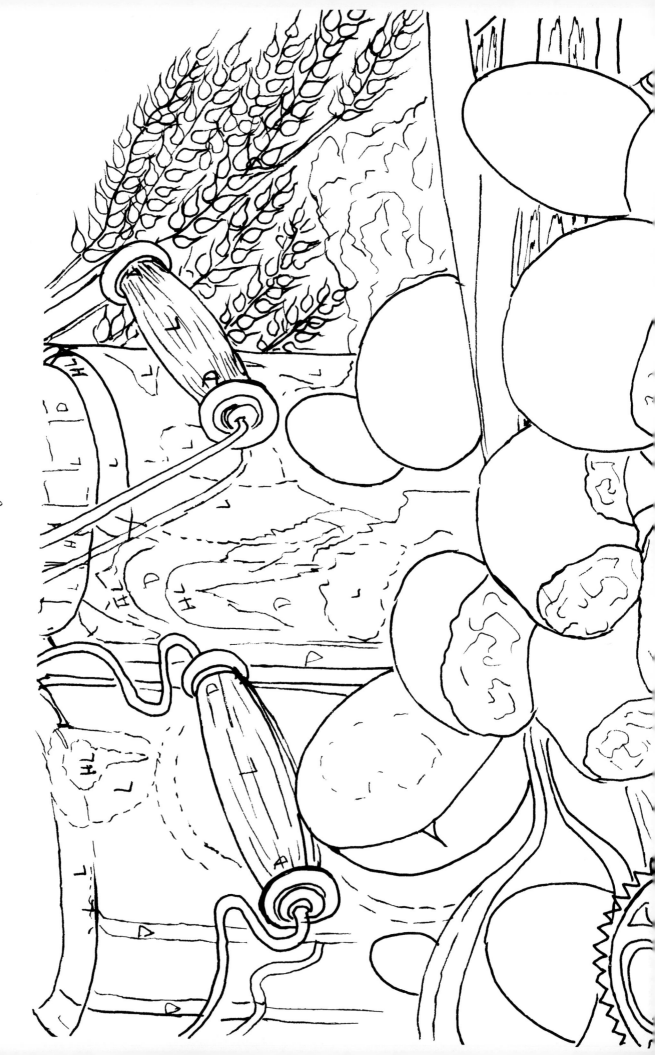

At the Bakery
Instructions on Pages 12-13

ANA BERNABE

At the Bakery
Pages 12-15

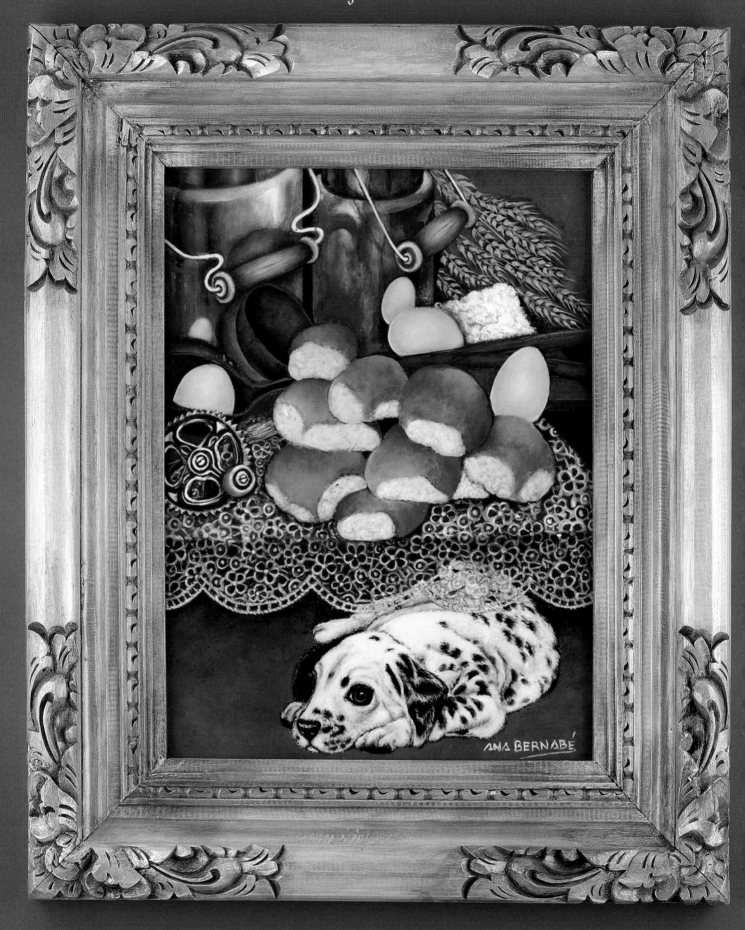

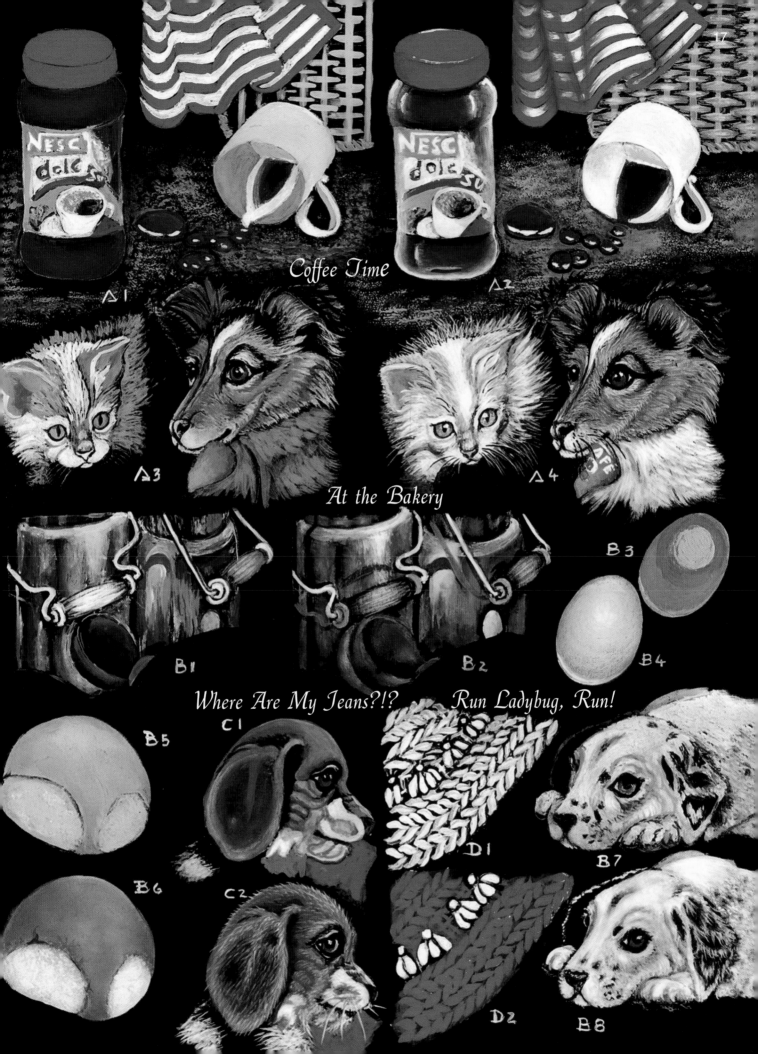

Coffee Time

At the Bakery

Where Are My Jeans?!?

Run Ladybug, Run!

Run Ladybug, Run!

Color Photo on Page 19

PALETTE
DELTA CERAMCOAT ACRYLICS
Black
Bright Red
Burnt Sienna
Cape Cod Blue
Dark Brown
Dark Goldenrod
Gamal Green
Georgia Clay
Golden Brown
Ivory
Kelly Green
Light Sage
Mocha Brown
Old Parchment
Payne's Grey
Salem Green
Sandstone
Sea Grass
Straw
Tangerine
White

SPECIAL SUPPLIES
Delta Ceramcoat Antiquing Gel, Black
Delta Ceramcoat Pearl Luster Medium
Stencil brush
Stencil with berries and leaves (to fit dimension of rim of plate)
Wooden plate (approximately 14" overall; 10" interior diameter)

PREPARATION
Please refer to "Surface Preparation" in the "General Instructions" at the front of the book.

RIM: Basecoat with slightly diluted Straw using a 3/4" angular brush, and let dry. Apply Black antiquing gel on the carved edges, and then softly remove the excess with a cloth. This will bring out the carved relief of the frame and give it an aged effect. Let dry.

To decorate the rim, I chose a stencil design with small leaves and berries. Doubleload a stencil brush with Kelly Green and Sandstone, periodically adding a touch of Gamal Green to the brush, and stipple the leaves through the stencil, allowing random dark and light areas to provide dimension. When dry, touch up stems and add veins to the leaves using a #00 liner brush with Sandstone, Salem Green, Salem Green + Sandstone (1:1) or Kelley Green + Sandstone (1:1). Paint round berries using a #4 liner brush and Bright Red.

DESIGN AREA: Basecoat the design surface with Black + sealer (1:1). Let dry. Transfer the design.

PAINTING INSTRUCTIONS
FLOOR
Step 1: Referring to the line drawing, paint the floor with Ivory using a 1/2" angular brush, fading into the background as you approach the cat (marked by the lower dashed line on the line drawing). Don't forget to paint the small floor area that appears just above the cat's head. Let dry.

Step 2: With a #6 round bristle brush and Old Parchment, drybrush the floor starting at the bottom (against the inner rim of the plate), moving upwards towards the cat; begin fading into the Ivory basecoat as you pass the table leg. When dry, deepen the color near the bottom edge using the same brush and Straw.

Step 3: Create the shadow area under the cat using a clean brush with Cape Cod Blue. Refer to the line drawing; start drybrushing in the black area near the cat at about the top dashed line on the line drawing. Fade the shadow as you move down towards the lower dashed line and into the Old Parchment background created in step 2. Move back and forth between the light and dark areas until there is a soft gradation of color. Add additional Old Parchment, as necessary, to soften the color transition, and then add Payne's Grey to soften the transition between the Black area immediately under the cat and the Cape Cod Blue.

With the same brush and colors, add a soft shadow under the table leg.

KNITTED TABLECLOTH
Refer to color worksheet.

Step 1: Using a #4 liner brush and White, paint S-strokes, dots, and loose comma strokes and straight strokes to form the entire knitted surface, including those areas that will be painted red. Since red is a translucent color, the white undercoat will give the surface added depth.

Step 2: With the same brush and Bright Red, paint over the red areas of the tablecloth, being careful not to cover the stitches that will remain white.

Step 3: Stroke over the white stitches with Ivory, allow to dry, and then randomly paint some of the ivory strokes with Pearl Luster Medium.

LADYBUG
Undercoat ladybug with White using a #2 round synthetic brush; allow to dry, and then basecoat with Bright Red. When dry, use a #00 liner brush and Black to paint the dots, head and antennae, legs, and fine division line between the wings.

TABLE LEG
Doubleload a 1/2" angular brush with Ivory and Golden Brown and, using the chisel edge of the brush, paint strokes imitating wood grain. Let dry.

Use a #2 Ruby Satin flat brush to drybrush Ivory along the upper portion of each ring. With White and a #00 liner brush, add small highlights at the front of each ring and a small vertical highlight line on the section just below the rings.

Use a 1/2" angular brush to apply a Dark Goldenrod wash over the entire leg, and allow to dry. Clean the brush, and then float Burnt Sienna shading down both sides of the leg, softly under each carved area on the leg, next to the tablecloth, and around the base of the leg.

With a #00 liner brush and Black, outline each carved area, and the bottom of the leg where it sits on the ground, and paint a few fine veins on the leg.

FOLIAGE
Paint the grass behind the table with a #4 liner brush and Gamal Green, applying loose brushstrokes to define long, thin blades. Allow to dry. Overlap lighter Kelly Green blades and, once dry, paint shorter and lighter Sea Grass blades. When dry, use a liner brush and Black to lightly line between a few of the blades, as necessary.

CAT

Step 1: Use a #00 liner brush and White to paint hairs along all transferred lines. Let dry. Drybrush the muzzle and chin using White and a #2 round bristle brush; apply more paint to the center of each area to add relief.

Step 2: With a #2 round bristle brush and Georgia Clay, drybrush the side of the nose and towards the tear ducts, and the shadow under the neck. Clean your brush and drybrush Golden Brown over the bridge of the nose. Then use Old Parchment to add a small high-lighted area on the top of the nose and down the center of the bridge. This will give added shape to the area. With a 1/2" angular brush, apply a Dark Goldenrod wash over the entire cat.

Step 3: Continue painting White hair using a #00 liner brush. Reinforce the lighter areas on the muzzle, eyelids, and tuft in the center of the forehead. Add highlight hairs inside the ear.

Clean your brush and, with Tangerine, add hair on the chest, top of the paws, on the bridge and top of the nose, and right edge of the ear. With the same brush and Dark Brown, paint hairs to deepen shadows and paint dark markings, such as in the tear ducts and on area over the right eyelid. Highlight a few areas, as needed, by adding a random hairs with White.

Add Black hairs to the contour of the body, top of the head, the line to the right of the right eye, and randomly inside the ear. Also pull some short hairs from the white area around the eyelids and at the edge of the ear. Basecoat the nose with Burnt Sienna. When dry, highlight with Old Parchment using a #00 liner brush. With Black and a liner brush, paint the mouth, nostrils, divisions between toes, and the claws. Highlight some claws by lightly painting a Georgia Clay line down their center.

(Continued on Page 20)

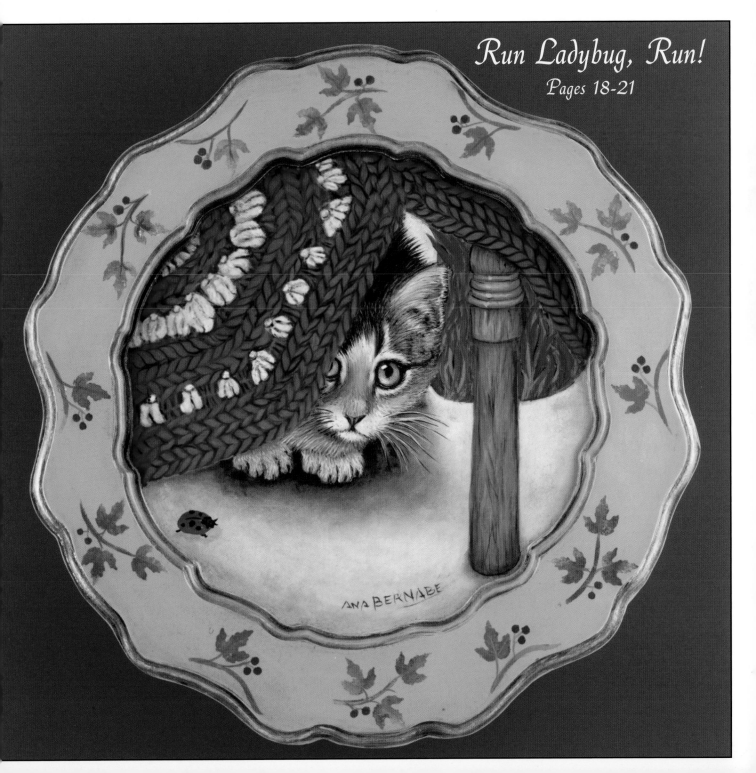

Run Ladybug, Run!
Pages 18-21

ANA BERNABE

Run Ladybug, Run!
(Continued from Page 19)

Using the same brush, paint thin Black and White lines, side by side (touching), for each whisker. Add a few freckles on the muzzle with thinned Mocha Brown.

EYES: Use a #2 round synthetic brush to basecoat the irises with White. Allow to dry, and then paint the irises with Sea Grass using the same brush. Use a #2 round bristle brush to drybrush Salem Green on the top portion of the irises.

Use a #2 round synthetic brush to apply Light Sage, starting at the bottom left of the iris and pulling your brush towards the right. Let dry. With a clean brush, apply a light Mocha Brown wash to a small area on the right of each iris.

Using a #00 liner brush and White, paint a curved shine line on the upper area of the right eye and a faint line on both lower eyelids.

FINAL TOUCHES
As needed, drybrush Black around the cat's paws.

FINISHING
Refer to "Finishing" in the "General Instructions" at the front of the book.

Run Ladybug, Run!

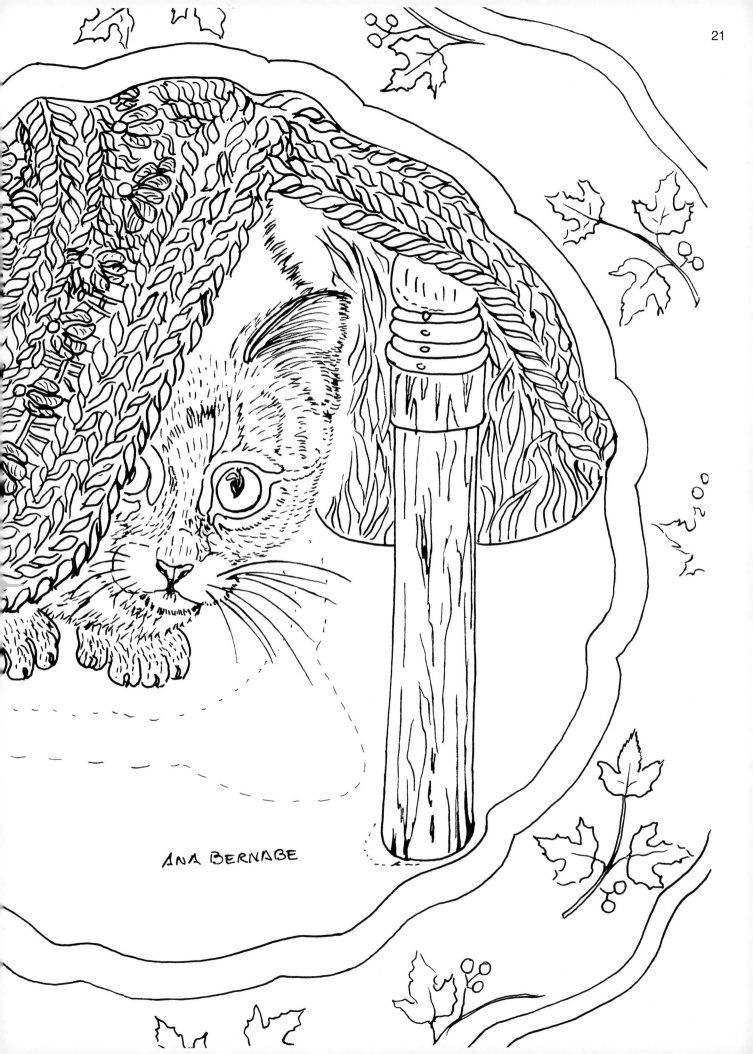

ANA BERNABE

A Cozy Nook

Color Photo on Page 23

PALETTE
DELTA CERAMCOAT ACRYLICS

Black	Glacier Blue
Black Green	Mocha Brown
Blue Jay	Phthalo Blue
Blue Velvet	Pink Angel
Burnt Sienna	Straw
Copen Blue	Ultra Blue
Dark Goldenrod	Wedgwood Blue
Georgia Clay	White

DELTA CERAMCOAT GLEAMS
Metallic 14K Gold

SPECIAL SUPPLIES
Delta Ceramcoat Pearl Luster Medium
MDF panel (approximately 11" x 16")
Wooden frame (overall measurement approximately 18" x 23")

PREPARATION
Refer to the "Surface Preparation" section at the front of the book.

FRAME: Use a 3/4" angular brush to apply thinned White to the frame. Let dry, and clean your brush. To form the illusion of wood veins, load your brush with White, touch the long corner in Wedgwood Blue, and use the chisel edge to apply short strokes along each side of the frame. Repeat, loading the brush with White, then tipping the brush into a very small amount of Black Green. Allow to dry.

Apply Pearl Luster Medium with a clean brush, and let dry. Clean your brush again, and use it to apply Metallic 14K Gold on the inner and outer edges. Let dry.

PANEL: Basecoat the surface with Black + sealer (1:1), and then allow to dry. Transfer the design.

PAINTING INSTRUCTIONS
BACKGROUND
Paint the area above the jeans using a 3/4" angular brush with Straw. While wet, add Burnt Sienna to your brush and slip-slap along the top edge of the panel, working down over the Straw area, lightly blending the two colors together to achieve a soft gradation of color. For the area below the jeans, use the same brush with Burnt Sienna, adding Straw to the brush and blending the colors as you move towards the bottom of the panel. Let dry. Using a #4 round bristle brush with Straw, drybrush the area to soften the transition from one color to the other.

JEANS
Please refer to figures 1 and 2 on the color worksheet.

Step 1: Using a 1/2" angular brush, apply Copen Blue in deeper areas; working wet-on-wet, apply Wedgwood Blue in the lighter areas of the folds and blend. Let dry.

Drybrush worn areas lightly with Glacier Blue, and then use a #00 liner brush and Glacier Blue to paint fine diagonal lines along the worn borders of the waistband and along the upper edges of the right pant leg, just above the cat's head. Work with the same color and brush to add a criss-cross pattern to the lighter areas of each fold, simulating the weave of the cloth.

With the #00 liner brush and Blue Velvet, paint a dark line along all the seams, and allow to dry.

Step 2: Using Straw, paint thin, broken lines for the stitching and around buttonhole. Let dry.

Using a 1/2" angular brush, apply a Phthalo Blue wash over the jeans and let dry. With the #00 liner brush, enhance some threads with Glacier Blue. Paint other threads with Copen Blue, pulling strokes towards the areas of shadow.

Using a 1/2" angular brush, float Phthalo Blue along the shadows between folds, to separate the front and back waistband, and to separate the right leg from the waistband. Let dry, and deepen the darker shadows by floating with Blue Velvet. Very lightly drybrush Straw over the top of some the folds to soften them and to add a more detail to the denim.

CATS
Please refer to step-by-step cat figures 1 and 2 on the worksheet. Both cats are painted using the same technique; the cat on the right has darker markings on the face and darker washes are used. The steps explained here are for this cat. Before beginning to paint, please read through the instructions to note the differences between the cats.

Step 1: Using a #00 liner brush with White, paint hairs along all transferred lines. Use a #2 round bristle brush and White to drybrush the muzzle area, top of the nose, cheeks (right below the eyes), and central area between the eyes. Use the same brush and color to add shape to the toes. Let dry, and then use a 3/8" angular brush to apply a Georgia Clay wash over entire cat. *NOTE: The dark, striped areas on the cats are formed as you wash Georgia Clay over the remaining black areas.*

As necessary clean up edges inside right ear and nostrils with Black. Using a #2 round synthetic brush, paint the nose with Pink Angel; outline it with Georgia Clay using a #00 liner brush.

Using a #2 flat brush, paint the inner left ear and the flap of the right ear with Pink Angel; add Georgia Clay toward the upper edge and randomly on the inner ear, blending lightly to form patches, and on the right ear flap next to the jeans.

Step 2: Paint a second layer of White hairs with a #00 liner brush. Also paint longer White hairs inside the left ear. Allow to dry.

Use a 1/2" angular brush to apply a Dark Goldenrod wash over paws and the entire face, except for the area around the muzzle and chin, which is lighter. When dry, use a #00 liner brush to paint Georgia Clay hairs on the top of the head, down the right side of the face, on the left side of face and on toes. With the same brush and Black, add a few hairs on the darker markings, on the contour of the head, and inside right ear. Let dry.

Paint the whiskers with a #00 liner brush, applying thin White and Black lines side by side (touching) for each whisker. This will give each individual hair both definition and continuity as it crosses dark and light areas. Load the liner brush with Georgia Clay, and then lightly touch the tip to the surface for each "freckle" on the muzzle area.

Using a #00 liner brush, paint the mouth with Georgia Clay. Use the same brush and White to reinforce lighter areas, also pulling a few short hairs over the mouth.

(Continued on Page 24)

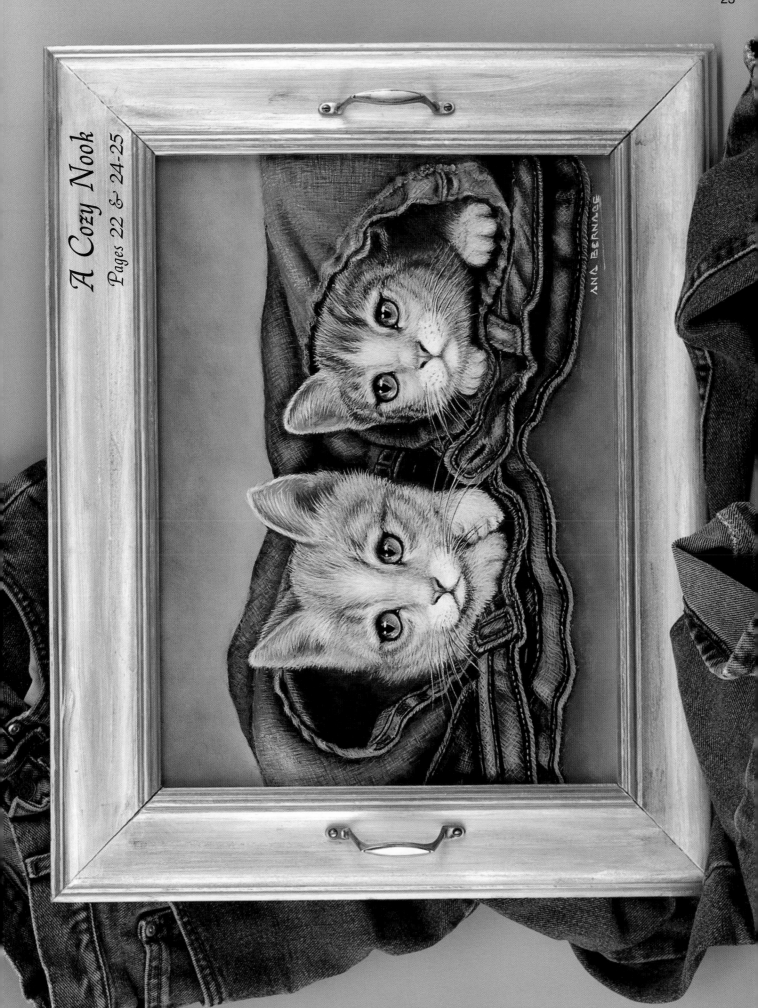

A Cozy Nook

Pages 22 & 24-25

ANA BERNADE

A Cozy Nook

(Continued from Page 22)

EYES:

Step 1: Using a #2 round synthetic brush, undercoat the irises with White, leaving the pupils black. Allow to dry, and then basecoat the irises with Blue Jay.

Step 2: With a #00 liner brush, add White and Ultra Blue dots to the base of the irises. Let dry, and then use a 3/8" angular synthetic brush to apply a Phthalo Blue wash over the eyes. Allow to dry.

Clean your brush and float White along the lower border of the irises. Once dry, use the same brush to float Phthalo Blue over the upper border. With a #00 liner brush and White, add reflective shine areas by painting a fine curved line and a dot on the upper portion of each eye.

As needed, clean up the outline around the eyes with a #00 liner brush and Black. Use the same brush to paint very short Burnt Sienna hairs along the inner edges of the upper and lower eyelids. This will add depth and realism to the eyes. Use the tip of a liner brush to lightly touch soft White dots in the tear ducts.

DIFFERENCES BETWEEN THE CATS: The cat on the left has lighter coloring than the one on the right. This is obtained by changing the colors of the washes. After the first layer of hair, apply a Mocha Brown wash. After the second layer of hair, apply a wash with Dark Goldenrod. Float a Burnt Sienna shadow in the lower central portion of both ears.

This cat also has Georgia Clay hairs in the darker areas, and a few Black hairs here and there, but no dark lines on the top of the head. Paint the mouth and "freckles" on muzzle with Black.

FINAL TOUCHES

Once both cats have been painted, reinforce shadows where the cats tuck into the jeans, as necessary. Use a #4 round bristle brush to lightly drybrush Black where the hairs meet the black background.

FINISHING

Please refer to the "Finishing" section in the "General Instructions" at the front of the book.

A Cozy Nook

ANA BERNABE

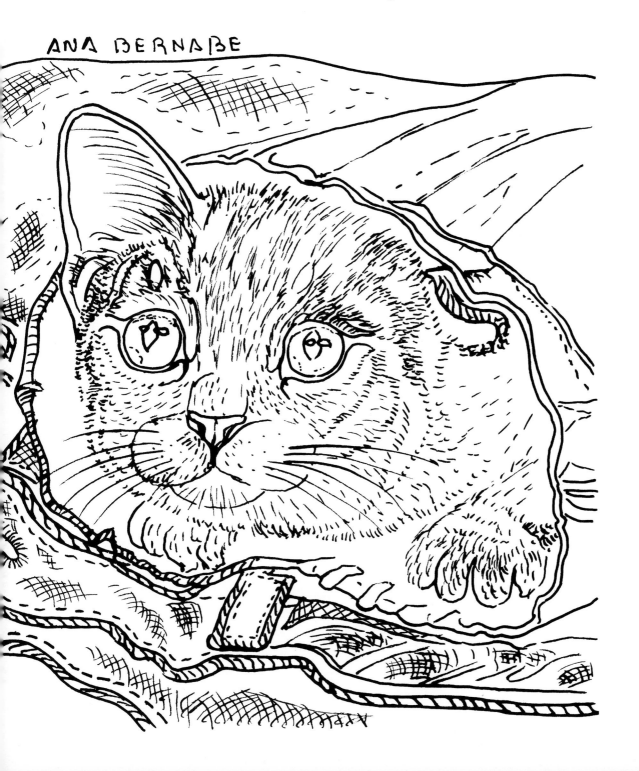

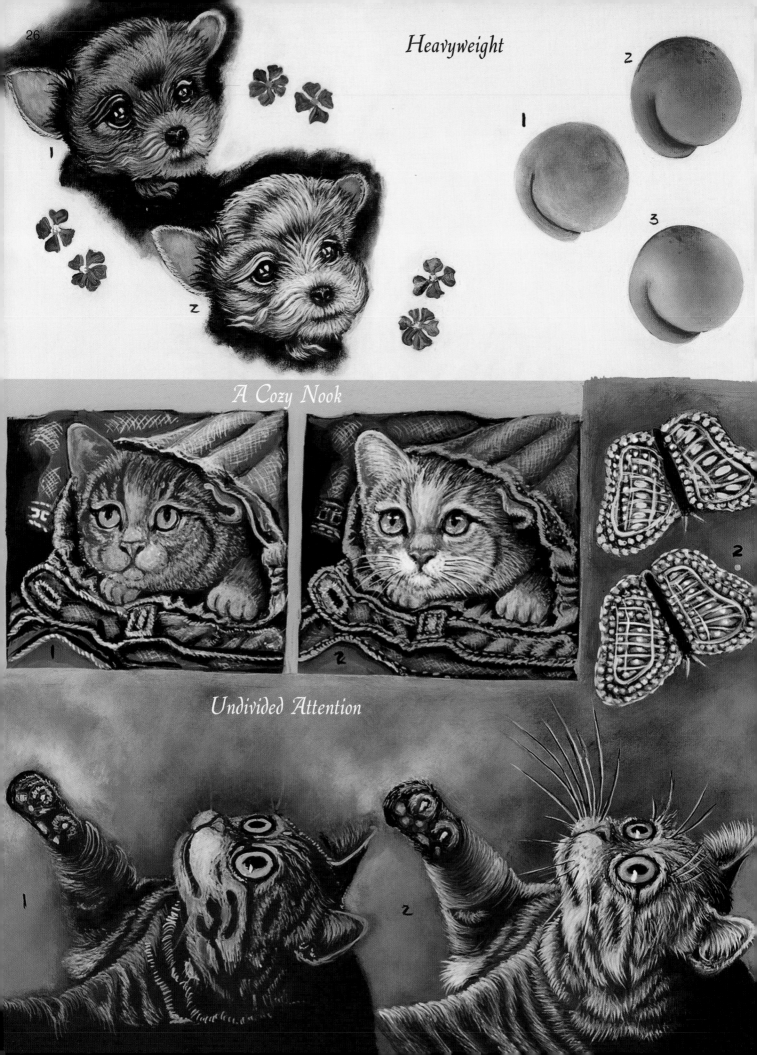

Heavyweight

A Cozy Nook

Undivided Attention

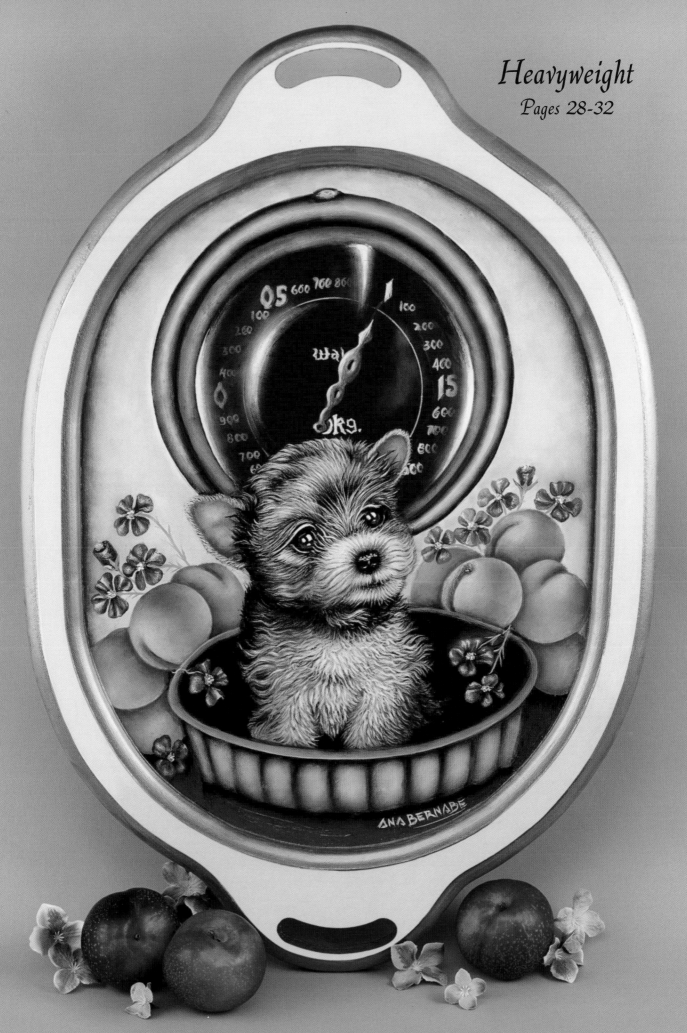

Heavyweight
Pages 28-32

Heavyweight
Color Photo on 27

PALETTE
DELTA CERAMCOAT ACRYLICS
Black
Blue Lagoon
Bonnie Blue
Burnt Sienna
Dark Chocolate
Dark Goldenrod
Georgia Clay
Ivory
Light Timberline Green
Midnight Blue
Mocha Brown
Mudstone
Pink Angel
Purple
Red Iron Oxide
Tangerine
Tide Pool Blue
White
Yellow
DELTA CERAMCOAT GLEAMS
Copper

SPECIAL SUPPLIES
Circle template, 4 1/2" diameter (or cardboard cut to size)
Oval wooden tray (overall dimensions approximately 16" x 23";
 design area approximately 12 3/4" x 16 3/4")
Permanent marker, fine point, silver

PREPARATION
Refer to the "Surface Preparation" section at the front of the book. Paint the tray's border with Ivory + sealer (1:1). Once dry, paint the rounded edges with Copper. Basecoat the design surface and back of the tray with Black + sealer (1:1). When dry, transfer the design, except for flowers.

PAINTING INSTRUCTIONS
Study the color worksheet in order to better understand the instructions. Before starting on the design, paint the wall around the dog, scale, and peaches with Ivory + Yellow (1: touch), using a 1/2" angular brush. Once dry, use a 1/2" angular brush to float Burnt Sienna around the inner edge of the tray, extending this float slightly into the areas where flowers will be painted. Let dry.

SCALE
BORDERS: The border around the upper portion of the scale (behind the dog) consists of two concentric circles with a knob at the top. To emphasize the roundness of these shapes, use a #4 round bristle brush and White to drybrush the center of each circular border and the center of the knob. Let dry.

Using a 1/2" angular brush and Midnight Blue, float shading around the inner and outer edges of the exterior border, and define the shape of the knob. Similarly, shade both edges of the interior border using the same brush with Burnt Sienna. Let dry.

To highlight the exterior border and the knob, drybrush the center of each using a #4 round bristle brush and Tide Pool Blue. Reinforce this highlight by drybrushing White over the brightest area of the exterior border. With a clean brush, do the same for the

(Continued on Page 30)

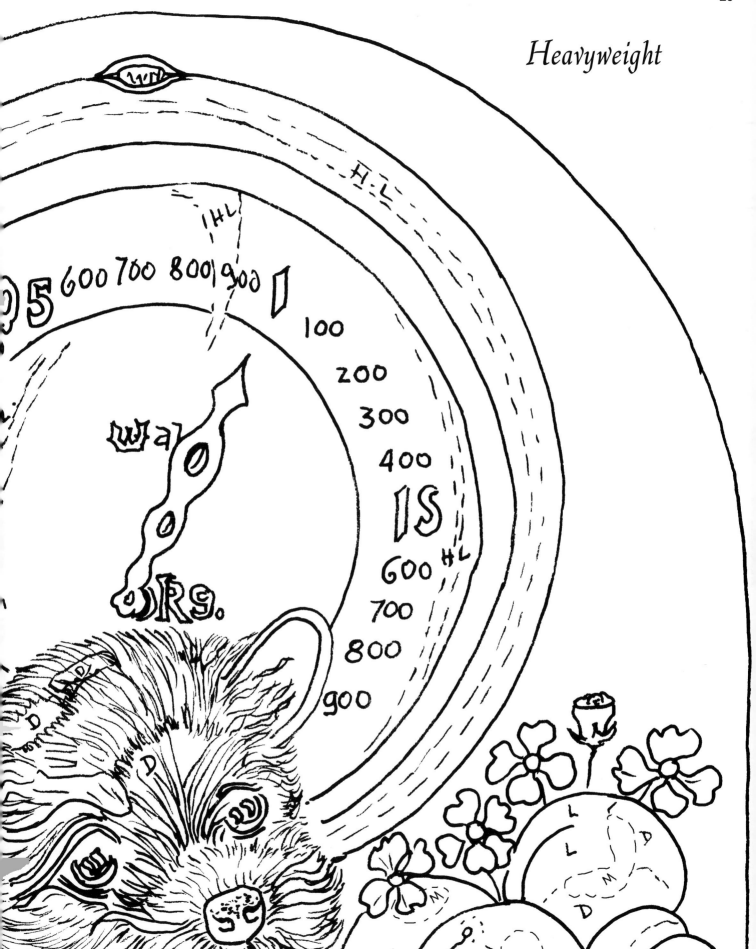

Heavyweight

Match and attach with the pattern section on pages 30-31

Heavyweight

(Continued from Page 28)

interior border, highlighting with Mocha Brown and reinforcing with Ivory.

FACE: Use a #00 liner brush and White to paint the numbers and letters. With a #4 flat brush, paint the needle starting along the right side with Burnt Sienna, blending with Dark Goldenrod as you move to the left edge. When dry, float a highlight down the left side of the needle with a 3/8" angular brush and White.

Outline the central circle (just inside the numbers) using a 4.5" (approximate) cardboard template and a silver-colored permanent marker. When dry, use a #6 round bristle brush to drybrush some Midnight Blue reflections on the black face. Continuing with Midnight Blue, drybrush the numbers to fade them slightly into the background.

Dull the reflection slightly by drybrushing a Burnt Sienna shadow just to the left of the top shine, and along the right side of each large number on the face of the scale. Clean the brush, and use White to drybrush shiny areas on the glass—down the sides, left center, and top of the face. Float White highlights down the sides; add back-to-back floated highlights on the top of the face.

BOWL: Using a #4 round bristle brush and White, drybrush the center of each segment on the side of the bowl to round its shape and allow to dry. Drybrush Dark Goldenrod down the sides and Mocha Brown on the base of each segment, always blending colors into each other.

With a 1/2" angular brush, float Midnight Blue down the divisions between segments and shade under the rim. Drybrush Mudstone and Bonnie Blue to add touches of color to the segments using a #4 round bristle brush. Paint the rim of the bowl using #4 flat brush and Mudstone, blending with White towards the outer edge.

Using a 1/2" angular brush and Burnt Sienna, paint the surface under the tray. Let dry, and then float Black shading under the base of the bowl, and below the peaches and single flower.

PEACHES

Step 1: Use a 3/8" angular synthetic brush to basecoat peaches with Ivory; let dry. Paint the clefts with a #00 liner brush and Dark Chocolate. Paint an Ivory dot with a #2 round synthetic brush to form the stem end on the peach that appears just above the top-right edge of the bowl. Outline the top half of the dot with a Black semi-circle.

With a #4 round bristle brush and Straw, drybrush the areas marked "L" on the line drawing. Drybrush the areas marked "D" with Dark Goldenrod, overlapping the areas so that they fade slightly into each other. Drybrush Georgia Clay in those areas marked "M" on the line drawing, softly blending into the previous colors. Dry thoroughly.

Step 2: Using a 3/8" angular brush, float Red Iron Oxide along the cleft of each peach, to form deeper shadows between peaches, and to round their edges (refer to color photograph). When dry, apply a Dark Goldenrod wash to the peaches. Let dry.

Step 3: Drybrush highlights over the lighter areas using a #4 round bristle brush and Ivory. Then use the same brush with Tangerine to softly integrate darker and lighter areas, being careful not to end up with uniformly orange peaches! Use the same brush to add random Yellow touches.

FLOWERS

With a #6 round bristle brush, drybrush Burnt Sienna inside the bowl where the top flower on the right will be painted. To paint the flowers and buds, load a #4 liner brush with Purple and touch the

Heavyweight

Match and attach with the pattern section on pages 28-29

tip into Blue Lagoon. Form each petal by pulling loose strokes from tip to base. Let dry. With a clean liner brush, paint White highlights on the petals as seen on the color photograph. As desired, drybrush or float additional Purple accents here and there on the petals to add depth and dimension.

Paint flower centers with Dark Goldenrod; once dry, add small White dots in each center. Use a #00 liner brush and Light Timberline Green to paint stems. With the same brush, add Black shadows to the flower stems within the bowl, and then add a few random White highlights to the stems.

DOG

Step 1: With a #00 liner brush and White, paint a layer of hair in the head area, pulling your strokes in the direction of hair growth (following the transferred lines); avoid the areas where the dog has

ANA BERNABE

darker spots. Using a #4 liner brush and White, paint tufts of hair on the body.

Using a #2 round bristle brush, drybrush Georgia Clay to fade the beginnings of brushstrokes around the spot areas on the head, corners of the mouth, shaded area of neck, and over the left eye. Working wet-on-wet, also apply Georgia Clay around the inner edge of each ear, blending with Pink Angel towards the center. Use a 1/2" angular brush to wash Dark Goldenrod over the entire dog. With a #2 round brush, paint Black hairs in ears.

Step 2: To make the hair look fluffy, especially in those areas of greater volume, use a #00 liner brush and White to randomly apply a new layer of light hairs on the head, and to add shape to the tufts on the body and sides of the muzzle. Remember not to completely cover the previous layer.

Clean your brush and use Tangerine to continue adding shape to the individual tufts of hair on the body and sides of muzzle. Also paint hairs around the nose, below the mouth, on the top of the head, and on the eyebrows with Tangerine.

With a clean brush and Burnt Sienna, paint hairs in the dark areas of the head, always starting from the black spots and pulling outwards. Also use Burnt Sienna to reinforce tufts around the muzzle, shaded areas of the neck, and sides of the body.

When dry, use the #00 liner brush with Black to paint hairs, starting on the dark spots and pulling outwards, overlapping some of the Burnt Sienna hairs. Paint Black hairs inside the ears (where they join the head), and around the head and body, always starting

(Continued on Page 32)

Heavyweight
(Continued from Page 31)

from a dark spot. Paint a few random hairs with Black in the following areas: between the front legs; on the outer edge of the right leg; on the left side of body and where the fur fades into the base of the scale; and very sparingly over the edges of the mouth.

Clean the brush again and randomly apply White highlights around the muzzle, on upper eyelids, and around outer edges of ears. As a last step, add the long White hairs between the eyes and randomly add White highlights to the tufts covering the body.

NOSE: The base color of the nose is the Black basecoat. Define the nostrils with a #00 liner brush and White. Also use White to apply highlight dots to the top of the nose, and to paint two small horizontal curved lines to define the bottom edge of each nostril.

EYES: Use a #2 round synthetic brush and Burnt Sienna to paint the irises. With a #2 round bristle brush and Black, drybrush the pupils, softly fading the line between the pupil and the iris (this will make the eyes look more natural). With White and a #2 liner brush, add the bright highlights. Using White, also paint a line on the rim of both lower eyelids, and then paint the top eyelids. With the same brush and thinned Tide Pool Blue, add soft highlights just above the left iris and very faintly at the top and bottom of the right iris.

FINISHING
Refer to "Finishing" in the "General Instructions" at the front of the book.

Undivided Attention
Color Photo on Page 33

PALETTE
DELTA CERAMCOAT ACRYLICS
Apple Green
Black
Blue Wisp
Bonnie Blue
Burnt Sienna
Dark Goldenrod
Georgia Clay
Ivory
Lime Green
Mocha Brown
Phthalo Blue
Pink Angel
Sea Grass
Tangerine
White
Yellow

SPECIAL SUPPLIES
Adhesive to glue cord to case
Cotton cord (long enough to frame the lid)
Wooden case (approximately 11" x 16")

PREPARATION
Refer to "Surface Preparation" in the "General Instructions" section at the front of the book. Basecoat the sides and back of the case with Ivory + sealer (1:1). Basecoat the front with Black + sealer (1:1). Let dry completely, and then transfer the design.

PAINTING INSTRUCTIONS
Please refer to the color worksheet. This cat is a good lesson on how to paint animals that have spots or stripes. It is important to be very careful with the color changes between stripes and around spots. You must be careful not to end up with perfectly defined division lines between colors. In real animals, this color change occurs along a fuzzy sort of line; more so when the color change is between contrasting colors, as is the case with dalmatian dogs (black and white spots), tigers, zebras, or cats like the one in this project.

To accomplish this realistic effect, soften the edges of the division lines using the drybrushing technique and an appropriate color such as Georgia Clay. Then use a liner brush to paint light-colored hairs that start in the lighter areas and slightly overlap the darker areas. In the same way, paint dark hairs starting from the dark areas and overlapping the lighter spots or stripes. When doing this, always follow the direction of hair growth. The end result will make your projects look more natural and realistic.

BACKGROUND
Paint the background around the transferred design using the drybrushing technique with a #8 round bristle brush. Remember to paint with circular movements of your hand, holding the brush at a 45-degree angle to the surface. If your brush gets too sticky with paint, clean and dry it thoroughly before you continue painting.

Start by painting fuzzy White clouds in the lighter areas and Burnt Sienna clouds for the darker ones. Then use Dark Goldenrod to integrate these areas and obtain a smoother transition from light to dark, softly blending and fading colors into each other. Continue adding and integrating other earthy colors such as Mocha Brown and Georgia Clay, concentrating the darker colors around the areas where the head and lower leg of the cat will be painted. Reinforce light areas with Ivory, and then add a soft Blue Wisp light around the raised paw and behind the head.

Use the same colors and technique to softly paint the sides and back.

EYES
Step 1: Apply an undercoat of White to the iris portion, and let dry. Basecoat with Apple Green using a #2 round synthetic brush, and then blend with Sea Grass towards the outer edge of each iris. Let dry, and clean your brush.

Step 2: Load the same brush with a small amount of Lime Green and apply next to the pupils. Let dry, and clean your brush. With

*Match and attach with the pattern
section on page 35*

the same brush, apply a soft Dark Goldenrod wash along the right edge of each iris. When dry, use a 3/8" angular brush and a touch of White to float a soft, thin line on the top and bottom edges of the right eye. With Bonnie Blue, add a softly curved line across the right side of each iris, allow to dry, and then add a White highlight, overlapping the lower edge of the blue line.

BODY

Step 1: Use a #00 liner brush and White to paint hairs along all transferred lines on the body and head of the cat. Add extra White hairs on the muzzle, chin, and above the eyes. Let dry.

Use a #2 Ruby Satin flat brush and Ivory to drybrush the pads. When dry, drybrush Mocha Brown shading around edges of pads. Paint claws with White. Use a 1/2" angular brush to apply a Georgia Clay wash over the entire cat, avoiding the eyes.

Step 2: Use a #2 round synthetic brush to paint the inner ears with Georgia Clay, blending with Pink Angel towards the center. Paint the nose with Pink Angel and define the edges with Georgia Clay. With the tip of the brush, lightly stipple the nose with White, and then touch up the nostril with Black. With a #00 liner brush, add a second layer of White hair over the body and the long hairs coming out from inside the ears. Let dry.

Step 3: Using a #4 round bristle brush and Georgia Clay, drybrush along the roots of hairs in these areas: inner ears, dark spots on the face, stripes along the legs, paw, and top of muzzle. This will disguise the beginnings of brushstrokes along the body. Repeat with Burnt Sienna, starting from the Georgia Clay areas and moving towards the darker areas. Reinforce by drybrushing with

(Continued on Page 36)

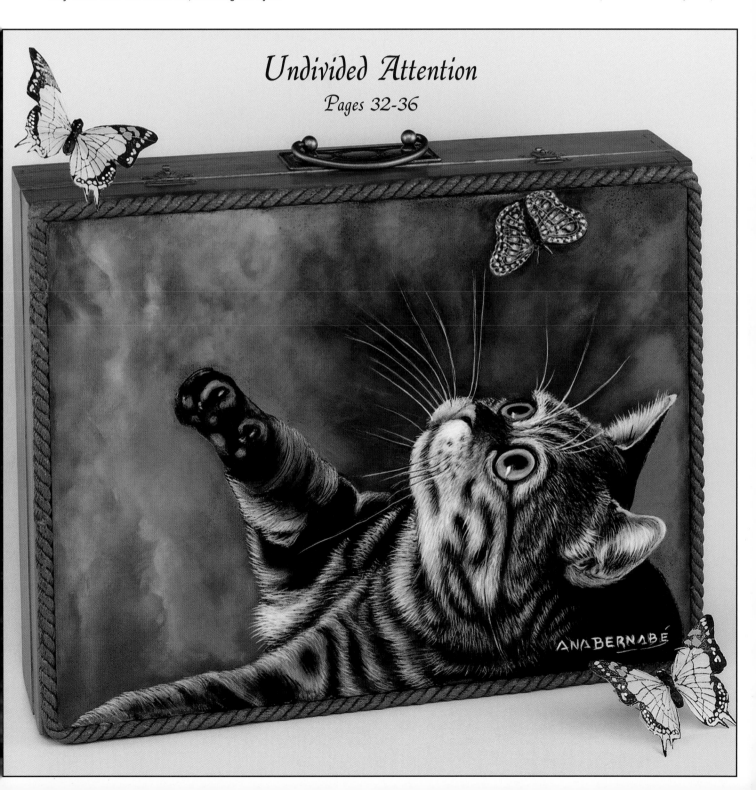

Undivided Attention
Pages 32-36

Undivided Attention

Instructions on Pages 32-33 & 36

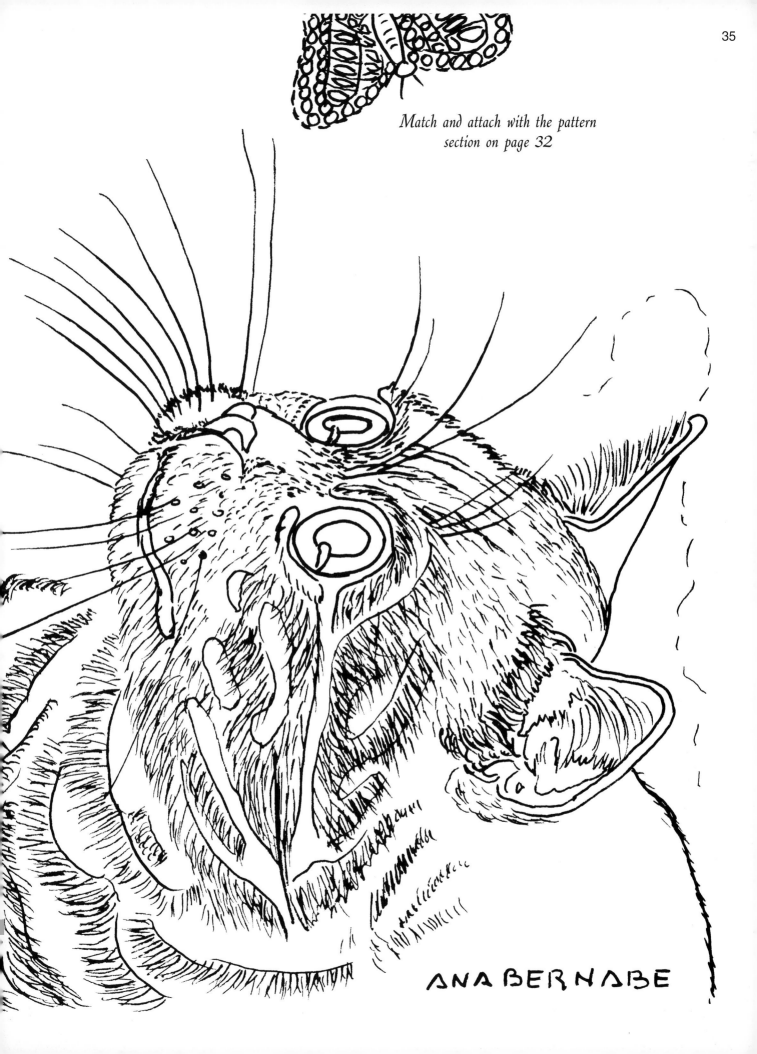

*Match and attach with the pattern
section on page 32*

ANA BERNABE

Undivided Attention

(Continued from Page 33)

Black down the center of each stripe and spot, trying to soften all division lines.

Use a #4 round bristle brush and Yellow to drybrush the chest area just below the raised leg, some areas of the chest, around the large spot on the right leg, along the top of left leg, and under the right leg. Define some hairs in the chest area with a #00 liner brush. Using a #4 Ruby Satin flat brush and Burnt Sienna, softly drybrush along the line of the mouth, and on the inside of the upper and lower eyelids.

Step 4: Add highlights to the hair and reinforce lighter areas with White and a #00 liner brush; paint a sparser coat of longer hairs, always starting in the lighter areas and slightly overlapping the darker spots and stripes. With the same brush and Black, do the same with dark hairs, starting from the dark areas and over-lapping the lighter spots or stripes. Add a few Black hairs to deepen the dark area inside the ears.

Add a few freckles on the muzzle using a #2 round synthetic brush and thinned Mocha Brown. Use a #00 liner brush to create whiskers by painting thin White and Black lines side by side (touching) for each whisker. This will give each individual hair both body and continuity as it crosses dark and light areas. Paint long eyebrow hairs with White. With the same brush, highlight claws with White, and then add short Black hairs to the top of the nose.

BUTTERFLY

Please study the color worksheet as you paint the butterfly.

Step 1: If necessary, transfer butterfly, and then basecoat with Black. Use a #2 round synthetic brush and White to outline all transferred lines. Let dry. Apply a Yellow wash with a 3/8" angular brush, and let dry again.

Step 2: Use a #2 round synthetic brush to paint alternate Ivory and Tangerine dots around the edges of the wings. Paint a Tangerine oval spot in each section in the central area of the wings (as seen on the worksheet). Once dry, add an Ivory dot in the center of each oval. Reinforce highlights by adding White dots around the wing. Lightly stipple the body of the butterfly with White. Use thinned White to highlight the lines that separate the spots on the wings and to paint the antennae.

FINISHING

Dye the cotton cord with diluted Burnt Sienna, and let dry. Keep in mind that the cord could shrink a bit when it dries, so cut it after it has dried completely. Glue it around the lid, and let glue dry. Refer to "Finishing" in the "General Instructions" at the front of the book for directions on how to protect your project, also varnishing over the top of the cording.

Pattern on Pages 34-35

Breakfast

Color Photo on Page 38

PALETTE
DELTA CERAMCOAT ACRYLICS

Antique Gold	Ivory
Black	Mocha Brown
Blue Jay	Mudstone
Blue Lagoon	Payne's Grey
Blue Mist	Red Iron Oxide
Blue Wisp	Royal Plum
Bridgeport Grey	Sandstone
Burnt Sienna	Storm Grey
Cape Cod Blue	Straw
Dark Brown	Tangerine
Dark Goldenrod	Ultra Blue
Drizzle Grey	Wedgwood Blue
Gamal Green	White
Georgia Clay	Yellow

SPECIAL SUPPLIES
Carved wooden frame (overall dimension approximately 21 1/2" x 23")
Delta Ceramcoat Antiquing Gel, Brown
Delta Ceramcoat Pearl Luster Medium
MDF or Masonite panel (approximately 16" x 20")
Natural sea sponge (small)
Old flat brush

PREPARATION
Please refer to the "Surface Preparation" section at the front of the book.

FRAME: Use a 3/4" angular brush to apply diluted White to the frame. Let dry. With a clean brush, apply Pearl Luster Medium.

When dry, apply Brown antiquing gel to the frame, and then softly clean the excess with a soft cloth. This will bring out the carved relief of the frame and give it an aged appearance. As necessary, highlight the high relief areas with Pearl Luster Medium. Let dry.

PANEL: Basecoat the entire panel with Royal Plum + sealer (1:1). Let dry. Transfer the outline for the oval section on the breadbox, then basecoat oval section with Black, using a 1/2" angular brush. When dry, transfer the design.

PAINTING INSTRUCTIONS
Please refer to the "Breakfast" color worksheet.

WINDOW
Paint the sky using a 1/2" angular brush and Blue Wisp. When dry, drybrush random Straw patches using a #4 round bristle brush. With a #2 round synthetic brush, paint the Black iron frames of the windows. Doubleload a 1/2" angular brush with Burnt Sienna and Mocha Brown, and then use the chisel edge to paint the wooden window frame, simulating wood grain. Float shading on the window sill with Burnt Sienna and a #4 flat brush.

FOLIAGE
Refer to foliage figures 1 through 3. To paint this foliage, use the edge of an old flat brush to stipple the colors in layers, starting with the dark shades and moving to the lighter ones; allow each layer to dry before proceeding. Load the edge of your brush and pounce the brush on the palette to separate the bristles.

Begin by softly stippling a layer of Gamal Green. Next, apply a Dark Goldenrod layer, and then add a light stippling of Straw here and there. Once dry, add highlights to the tips of branches with Ivory. You can use other colors to make this foliage your own

personal creation! As a last step, use a #00 liner brush and Black to intersperse branches here and there. Paint black birds with the same brush and Black.

To allow the sky to show through some areas of the foliage, stipple the sky color (Blue Wisp) near the "Vs" formed by the branches.

CURTAIN

Refer to curtain figures 1 through 5.

There is a small fringe of curtain at the top of the window, just a wisp of scalloped lace. Use a liner brush with White to define the scallops and to paint a curved line just below each scallop. Paint vertical lines suggesting that this lower edge is a drawn thread border, which is joined to the upper portion of the curtain, and then add tiny scallops all along the border.

With a 3/8" angular brush and Drizzle Grey, float down both sides of each scallop to add shadows at the sides of each border section. Add random highlights to the lace using a liner brush with White. Drybrush a highlight down the center of each scallop using a #4 round bristle brush with White. As needed, use a #2 round synthetic brush with Black to tidy up opening areas in the lace.

BREADBOX

Refer to breadbox figures 1 and 2. As you create the breadbox, also paint the area that will be visible through the glass jar.

Step 1: Doubleload a 1/2" angular brush with Mocha Brown and White. To create the appearance of wood grain, use the chisel edge of the brush to apply horizontal strokes on the front and scalloped back of the box, and vertical strokes on the side edges of the box. Paint the upper, curved edge of the box with Ivory and a #2 round synthetic brush. Clean the brush, and then paint the inner edge of the oval (where the kitten is hiding) with Mocha Brown. Load the same brush with Mocha Brown, touch the tip in White, and paint the vertical wicker ribs and the wide horizontal wicker borders within the oval. When dry, float shadows on inner edge of oval with a 1/2" angular brush and Burnt Sienna.

Create the woven, horizontal wickerwork with a #00 liner brush and Mocha Brown, painting the strokes over alternating ribs in each row. Let dry.

Step 2: Use a 1/2" angular brush to float Burnt Sienna around the outside of the oval. Then clean the brush and float White on the outer edge of the oval.

With White, softly highlight the center of each woven segment, paint faint vertical lines over the top and bottom wicker borders, and highlight along the front edges of the right side of the box. Let dry. Then apply a Dark Goldenrod wash over the entire box (and wickerwork) using a 1/2" angular brush. Once dry, float Georgia Clay along the lower edge of both wickerwork borders. Use a #4 Ruby Satin flat brush to drybrush Georgia Clay over some of the wicker segments. Using a liner brush with Black, outline the wicker segments.

Shade the inner edge of the right side with Burnt Sienna; shade the inner front edge of the left side with Mocha Brown. As needed, drybrush Black to deepen shadow between front and back of box. With very thin Payne's Grey, shade the left front edge (where it meets the side), lightly at the low points of the top cut edge, and within the box on the left side.

CAT

Please refer to figures 1 and 2.

Step 1: Use a #00 liner brush with White to paint hairs along all transferred lines on the head, white markings around eyes, and paint toes. As you paint the face, use the same colors and a #2 round synthetic brush to paint the paw.

Use a #2 round synthetic brush to basecoat the irises with White. Allow to dry, and apply Blue Lagoon with the same brush. Drybrush Ultra Blue shading on the upper portion of each iris with a #4 Ruby Satin flat brush. If needed, touch up the pupils with Black. With a #00 liner brush and White, paint a curved shine line on each eye.

Step 2: Use a 1/2" angular brush to apply a Dark Goldenrod wash over the face, except for the eyes and the White area around them. Paint hairs with a #00 liner brush and diluted Georgia Clay, and allow to dry. Paint a second layer of White hair; then, once dry, apply a second Dark Goldenrod wash, covering the same area as the first wash.

On the paw, define the divisions between the toes with a #00 liner brush and Black. Add a short White line between each division to define the claw, and then shade each claw with a soft Black line.

Use your liner brush and White to reinforce the area around the eyes. Clean the brush and paint a few random Black hairs on the eyebrows and around the eyes. Also with Black, tidy up the lower edge of the nose, and then use the same brush to add a few Ivory hairs on the nose.

With a #4 round bristle brush and Black, drybrush the area on the top of the head that fades into the shadows within the box.

MARMALADE JAR

Refer to marmalade figures 1 and 2.

MARMALADE: So that the outline of the glass jar is not lost while painting the marmalade, use a #00 liner brush with White to lightly paint over all of the jar's transferred lines, such as the shape outline, screw threads, and shine areas.

Use a 1/2" angular brush with White to paint the marmalade, defining two areas of greater intensity, one near the bottom and the other near the upper edge. Continuing with White, use a #2 round synthetic brush to paint the lumps on the surface of the marmalade. With the angular brush, paint the whole contents of the jar with slightly thinned Tangerine, and allow to dry. Reinforce the light areas of the marmalade with the same brush and White. Let dry, and then apply a Yellow wash to the entire marmalade area. Drybrush Georgia Clay towards the left edge, and deepen shadows near the base with Burnt Sienna. Deepen the shadows around the lumps on the top surface of the marmalade with thinned Georgia Clay and thinned Burnt Sienna.

GLASS: When you paint the transparent glass jar, remember that the breadbox must remain visible behind the glass. Use a #00 liner brush with Drizzle Grey to paint the upper rim of the jar and the curved thread lines. Using a 1/2" angular brush, float with Drizzle Grey to form the edge of the upper-right side of the jar (below the threads) and the small area of light on the lower-left side of base.

Highlight a few of the threads with Blue Lagoon, and then apply a light wash of Blue Lagoon over the white highlight and shine areas. Once dry, use a #00 liner brush with White to reinforce the curve of the thread lines, and to define the more intense and random highlights along the left side and front of the glass. Let dry.

Using White and a 1/2" angular brush, apply a back-to-back float to the two central area highlights on the jar. Float White down the upper-right side and on left side of the jar (below the threads). Also paint two small and lighter highlights that follow the upper curve of the glass. Continuing with undiluted White, use a #2 round synthetic brush to reinforce the center of the highlight areas.

(Continued on Page 38)

Breakfast

(Continued from Page 37)

PLATE, BUTTER, AND DOILY

PLATE: Use the 1/2" angular brush with Ivory to basecoat the plate, and allow to dry. Paint the outer edge of the rim of the plate with White, using a 1/2" angular brush. Also add a few White strokes here and there to the surface of the plate. Paint the shadow from the glass jar, the inner shading next to the rim, and shadow from the butter with Mudstone, using the same brush. Using a #4 round bristle brush and Antique Gold, drybrush the plate at the left edge of the butter and to form the marmalade reflection. Lightly wash Wedgwood Blue on the inner edge of the reflection area. When dry, drybrush a bright reflection with Georgia Clay.

BUTTER: Paint the lighter areas with Ivory and the shaded areas with Mudstone, using a #4 flat brush. Then use a 1/2" angular brush to apply an Antique Gold wash, and let dry. With a #2 round synthetic brush and diluted White, enhance the light edges and lighter areas in the butter. Reinforce the shaded edges with Mudstone, and then accent some of the shadows by floating with Antique Gold.

DOILY: Basecoat the doily under the dish with White, and then shade with Wedgwood Blue. With a #4 flat brush and very little White, enhance the lighter edge, slightly overlapping the shaded areas. Use a 1/2" angular brush to float Cape Cod Blue shading on the area immediately under the dish, and let dry. Using a #4 round

(Continued on Page 44)

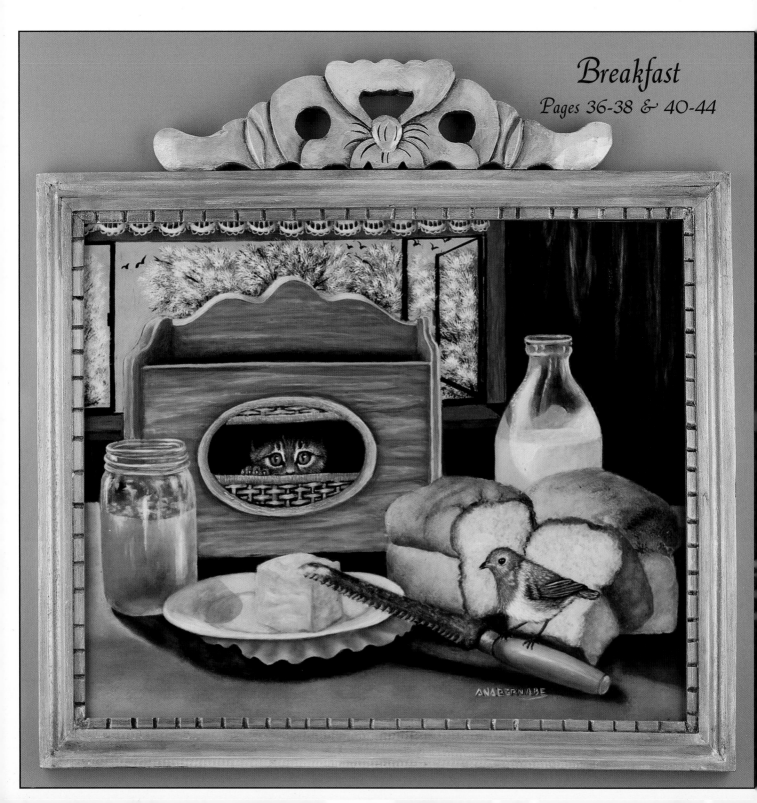

Breakfast

Pages 36-38 & 40-44

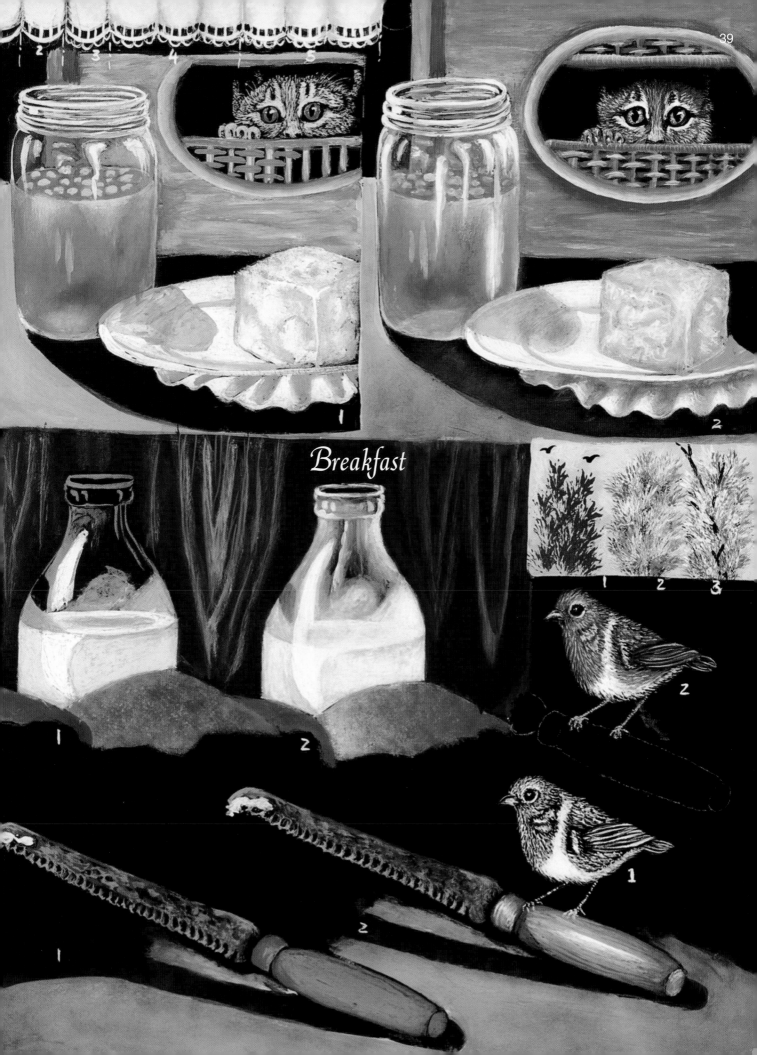

Breakfast

Breakfast

Instructions on Pages 36-38 & 44

Match and attach with
the pattern section on
pages 42-43

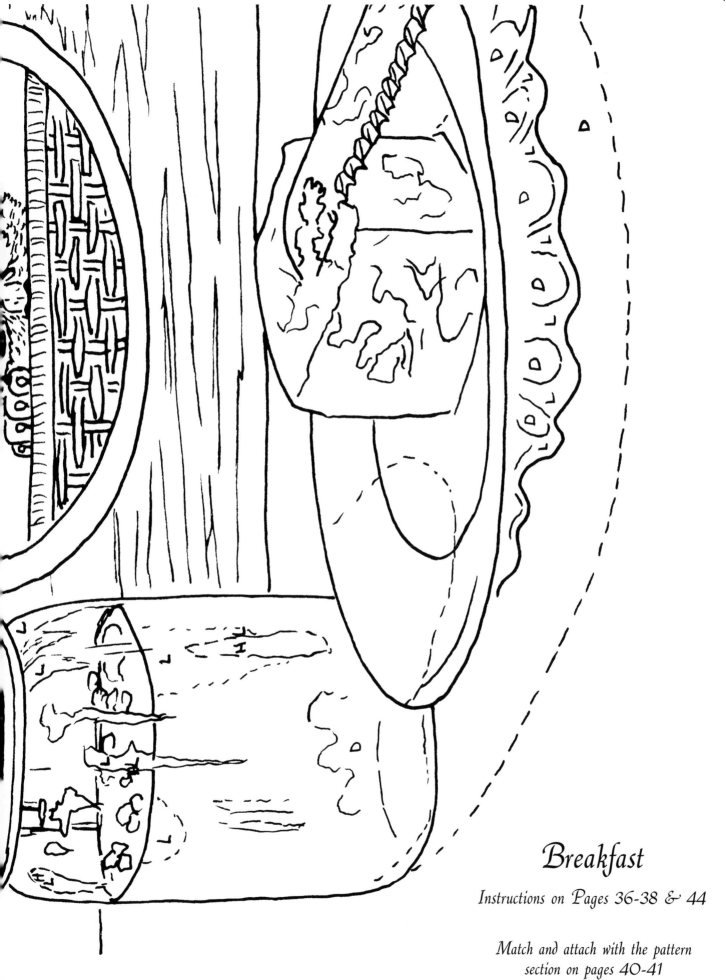

Breakfast

Instructions on Pages 36-38 & 44

*Match and attach with the pattern
section on pages 40-41*

Breakfast
(Continued from Page 38)

bristle brush, drybrush accents along the folds of the doily with Dark Goldenrod and Georgia Clay.

TABLE

Basecoat the entire table using a 1/2" angular brush with Straw, and allow to dry. Use a #6 round bristle brush to drybrush Georgia Clay over the table surface. Drybrush Royal Plum to form all deep shadow areas under the doily, knife, breadbox, loaves of bread, plate, and marmalade jar.

BACKGROUND WALL

With a clean brush and Drizzle Grey, use the chisel edge of the brush to paint vertical wood grain. Let dry. Apply a Georgia Clay wash over some of the grain lines. Once dry, use a #6 round bristle brush to drybrush Royal Plum over the ends of the most contrasting grain lines to softly fade them into the background.

MILK BOTTLE

Refer to milk bottle figures 1 and 2.

Step 1: Paint the transferred lines using a #00 liner brush with Blue Mist. Using a 1/2" angular brush, follow the color map shown in figure 1, applying Blue Jay to the darker areas, Blue Mist to the light areas, and White to the highlight areas.

Step 2: Using the 1/2" angular brush, apply a White wash over the milk surface. Once dry, enhance some areas on the top of the bottle using a #00 liner brush with White. Use the same brush to paint a broken line on the glass, forming the central vertical shine.

Use the 1/2" angular brush with White to enhance the main spot of light on the left side that appears above the milk, the light triangle below the milk's surface, and right side above milk. With the same brush, float Blue Mist down both sides of the neck, and let dry.

With a #2 round synthetic brush, dabble White down the left edge of the large shine area and down the center shine on the front of the bottle. Also add highlights on both rims at the mouth of the bottle, allowing them to fade slightly toward the right, and paint small commas in the space between the rims.

LOAVES OF BREAD

Please refer to the bread figures 1 and 2 on the color worksheet.

Step 1: With the 1/2" angular brush, basecoat the crust with Mocha Brown, and let dry. With the edge of an old stiff-bristled flat brush, softly stipple Red Iron Oxide over the surface of the crust using little paint. Allow to dry.

Step 2: Float shading with Dark Brown, let dry, and then apply a White wash over the lighter areas. Use a #00 liner brush with Burnt Sienna to paint fine, uneven lines, forming small cracks along the edges of the crust. Deepen some of these cracks and lines with Dark Brown.

Load a dampened sea sponge with Sandstone, remove the excess paint on a paper towel, and apply to form the soft part of the bread. Once dry, sponge Ivory over the same area, and let dry once again. As a final step, sponge area with Ivory + White (1: touch), and let dry.

KNIFE

Please refer to knife figures 1 and 2 on the color worksheet.

BLADE: Basecoat the blade with Black, and let dry. Use a # 2 round synthetic brush with thinned Storm Grey to paint random stains on the blade. When dry, repeat with thinned Bridgeport Grey to highlight some areas and define the serrated edge of the blade. Once dry, create additional stains using thinned Burnt Sienna. Add

a smear of butter to the end of the knife by drybrushing first with Ivory and then with White to highlight.

HANDLE: Use a 3/8" angular brush to basecoat handle with Mocha Brown, and let dry. Working quickly so the paint remains wet, apply a second coat of Mocha Brown on the outer edges and White towards the center of the handle, blending the edges of the colors together. Let dry, and evenly apply a Dark Goldenrod wash with a 1/2" angular brush. When dry, lightly float Burnt Sienna shading along the upper portion of the handle. With a #00 liner brush and thinned White, paint the central highlight on the handle and the horizontal highlight lines on the upper portion of the handle. Clean your brush and paint fine Georgia Clay lines along the lower length of the handle. Paint fine Black lines to separate the areas of the handle.

BIRD

Step 1: As necessary, touch up the shape of the bird with Black, allow to dry, and then transfer any pattern lines that were lost. With a #00 liner brush and White, apply fine, short lines along the transferred lines; fill in white areas with overlapping strokes. Use the same brush to paint the eye, legs, and tip of beak with Black. Let dry.

Step 2: With a #00 liner brush, paint a layer of Georgia Clay feathers all over the body except for the white area around the neck, lower chest, and belly. Let dry. Use the same brush with White to paint a second layer of thin feathers over the body, without totally covering the underlying color, and allow to dry. Use a 3/8" angular brush to apply a Dark Goldenrod wash to the areas of color, being careful not to touch the white areas.

Use the liner brush and White to paint small horizontal lines on the legs and, once dry, apply a Dark Goldenrod wash. With White, enhance the beak and add a third layer of feathers on the belly.

Using longer strokes, paint the wing and tail feathers using the same colors as the rest of the feathers. Using a #00 liner brush with Black, enhance the tail feathers and also apply some short lines around the outline of the bird. Use the liner brush to add a White shine dot to the eye and beak.

FINISHING

Refer to "Finishing" in the "General Instructions" at the front of the book.

Pattern on Pages 40-43

Friends

Color Photo on Page 47

PALETTE
DELTA CERAMCOAT ACRYLICS
Black
Blue Lagoon
Bright Red
Dark Goldenrod
Georgia Clay
Glacier Blue
Kelly Green
Mocha Brown
Straw
Tangerine
Ultra Blue
Wedgwood Blue
White

SPECIAL SUPPLIES
Wooden tray with optional insert (approximately 12" x 15 1/2" overall)

PREPARATION
Refer to the "Surface Preparation" section at the front of the book. Basecoat the tray, including the sides, handles, edges, and bottom, with Dark Goldenrod + sealer (1:1), using a 3/4" angular brush. When dry, apply a second coat of Dark Goldenrod (without sealer). Basecoat the front and sides of the insert, or the center design area of the tray, with Black + sealer (1:1). Allow to dry thoroughly, and then, if needed, sand the surface with a fine-grit sandpaper so that the whole surface is very smooth. Remove any sanding dust with a clean cloth. Transfer the design, except ball of yarn and blanket folds.

PAINTING INSTRUCTIONS
BACKGROUND AROUND ANIMALS
Using Blue Lagoon with a 3/4" angular brush, paint background around animals. Allow to dry. Transfer fold lines for blanket, and then loosely float soft shading with Ultra Blue to establish the folds of the blanket.

CAT AND DOG
Before starting, study the color worksheets so that you will better understand the instructions. When painting hair, keep in mind that you must start the first layer of strokes near the outer edge of the design and work your way towards the center, always pulling each hair stroke from the base of the hair towards the tip.

When painting each successive row or layer of hair, slightly overlap the strokes of the previous row/layer in order to hide the base of the individual hairs or tufts. This will give your painting a natural and realistic look.

Worksheet 1: Thin White with water until the paint is the consistency of ink. This will help the paint flow from the brush. Using a #4 liner brush, paint tufts of hair to cover the legs of the dog and the body of the cat.

With a #00 script liner and White, paint hairs on heads and tails of both animals, and legs, back and paws of cat, pulling your strokes in the direction indicated by the transferred lines (direction of hair growth). Paint irises and let dry.

Clean the brush and use Georgia Clay to paint the lines on the cat's head, tips of ears, nose, and top portion of legs.

Worksheet 2: With a #4 round bristle brush and Georgia Clay, drybrush the shaded areas of both animals. Remember to pick up a small amount of paint and rub the brush on a paper towel to remove the excess paint. Apply lightly, leaving just a hint of color. With a #2 Ruby Satin flat brush, drybrush shading between the cat's toes with Mocha Brown. Deepen shading with Burnt Sienna, and allow to dry.

Using a 1/2" angular brush, apply a Dark Goldenrod wash over the body of the cat, avoiding the nose, eyes, white areas of the muzzle, chin, and light markings above and below the eyes. On the dog, apply a Mocha Brown wash over the body and irises, avoiding all black areas. Apply a wash of Kelly Green to the irises of the cat's eyes. Allow to dry completely.

EYES: Use a #2 flat brush with Black to drybrush the pupils in the dog's eyes, softly blending where the pupil meets the iris (this will make the eyes look more natural) and where the iris meets the shadow of the upper eyelid. With the same brush and Black, drybrush the top portion of the cat's irises.

Using a #00 script liner brush with White, add highlights to the eyes of both animals, applying small dots for the dog and a small, horizontal line for the cat.

Worksheet 3: To make the hair on both animals look fluffy and soft, apply another layer of very fine and dense White hair on all areas where hair is very light, such as on the top of the dog's face and on the cat's legs and toes. Continue to develop the cat's fur by painting random Georgia Clay hairs. Apply a second wash to the same areas using Straw (rather than Dark Goldenrod) for the cat and Mocha Brown for the dog. Let dry.

Using a #00 script liner brush and Tangerine (diluted to consistency of ink), intersperse hairs throughout the previous layers. This will add an additional touch of color to the animals. On the cat, also use this color to define (or outline) the individual tufts of hair. Clean the brush and, using White, add hairs on the cat to the muzzle, chin, around the eyes, and on the front edge of the ear flaps. On the dog, paint White hairs below the eyes, above the eyebrows, lightly just below the mouth on the muzzle, and on ears.

Using Black, sparsely paint hairs along the parted area on the top of the dog's head, over the eyes, and on the sides of the head, starting in the darker areas and overlapping the lighter ones. For the cat, use a #00 script liner brush with Black to add small hairs inside the ears and to define the nose, mouth, and neck areas. Finally, paint long White hairs above the dog's nose, lightly extending them over the bridge of the nose.

NOSES: The base color of the dog's nose is the original Black background. Use a #00 script liner and White to apply highlight dots to the dog's nose. Form nostrils with thinned White using same brush. Paint the cat's nose with Georgia Clay. Then add a touch of White to this color and highlight the nose, blending towards the center.

WHISKERS: Use a #00 script liner brush to paint thin White and Black lines side by side (touching) for each whisker on both animals. This will give each individual hair both body and continuity as it crosses dark and light areas.

(Continued on Page 50)

Friends
Pages 45 & 48-50

Worksheet 1

Worksheet 2

Worksheet 3

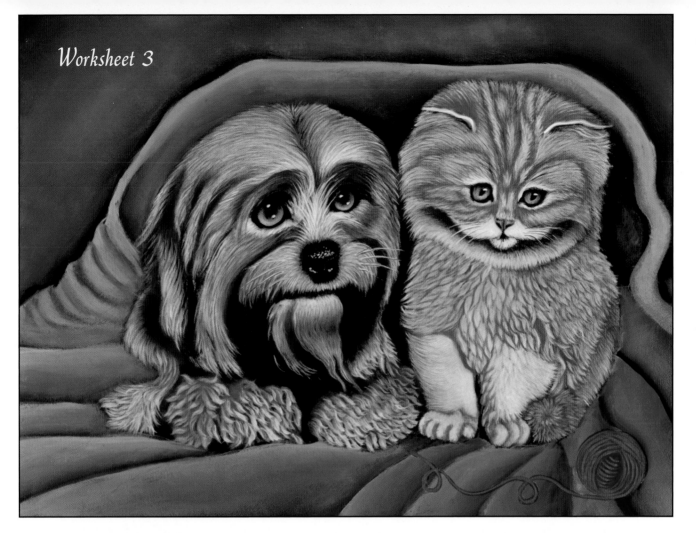

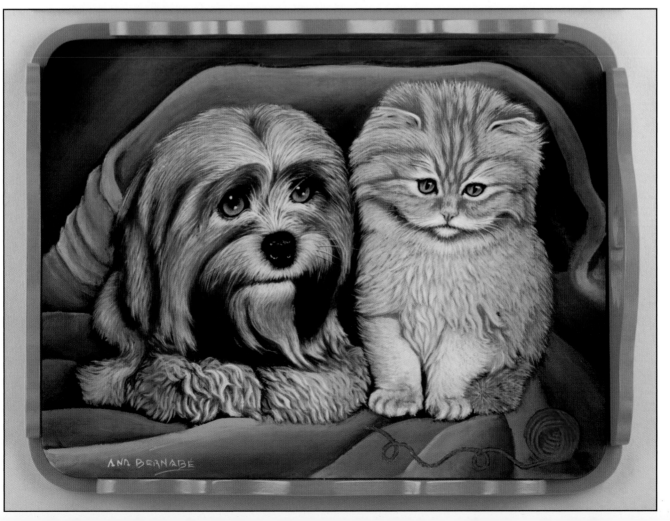

Friends

Instructions on Pages 45 & 50

ANA BERNABE

Friends

(Continued from Page 45)

Painted Project: Using a #00 liner brush and thinned White, paint a light line along the inside of the dog's lower-left inner eyelid. Reinforce the lighter areas by adding a layer of random White hairs. Once dry, apply a Dark Goldenrod wash over the cat and a Mocha Brown wash over the dog using a 1/2" angular brush. If necessary, add a few White highlights with a #00 liner brush. Add a last, very soft wash of Dark Goldenrod over both animals.

BLANKET

Paint the blanket with a 1/2" angular brush and apply colors wet-on-wet so that one can be blended into another. Start by applying Wedgwood Blue to the lighter areas, blending it with Blue Lagoon as you work your way towards darker shaded areas and, finally, blending with Ultra Blue as you reach the darkest shadows. Allow to dry.

Float deeper shadows with Ultra Blue using the same brush. Once dry, use the same brush and Glacier Blue to float brighter highlights on the lighter edges of the blanket.

BALL OF YARN

Transfer pattern for yarn when blanket is complete. Refer to the steps shown on the color worksheets. Use a #00 script liner brush with White to paint the ball of yarn, and allow to dry. Apply a wash of Bright Red, and let dry. Using a #00 script liner brush and thinned White, paint fine, short lines to form the twists in the individual strands.

FINISHING

If necessary, assemble and glue the insert and tray, and then refer to "Finishing" in the "General Instructions" section at the front of the book.

Pattern on Pages 48-49

The Visitor

Color Photo on Page 51

PALETTE
DELTA CERAMCOAT ACRYLICS

Black	Ivory
Black Green	Kelly Green
Blue Jay	Mocha Brown
Blue Lagoon	Old Parchment
Bright Red	Payne's Grey
Burnt Sienna	Phthalo Blue
Cape Cod Blue	Pink Angel
Dark Brown	Red Iron Oxide
Dark Goldenrod	Sandstone
Dolphin Grey	Sea Grass
Gamal Green	Soft Grey
Georgia Clay	Stonewedge Green
Glacier Blue	White
Golden Brown	

SPECIAL SUPPLIES
Carved wooden frame (approximately 18" x 23")
Delta Ceramcoat Antiquing Gel, Brown
Delta Ceramcoat Pearl Luster Medium
MDF or Masonite panel (approximately 11" x 16")

PREPARATION
Please refer to "Surface Preparation" in the "General Instructions" at the front of the book.

FRAME: Basecoat the frame using a 3/4" angular brush and White, slightly thinned with water. Let dry, and clean your brush. Apply Pearl Luster Medium with the same brush. When dry, apply Brown antiquing gel over the carving on the frame, and then lightly remove the excess with a cloth. This will bring out the carved relief of the frame. If necessary, highlight the areas of high relief with Pearl Luster Medium. Let dry.

PANEL: Basecoat the surface with Black + sealer (1:1) and let dry. Transfer the design, omitting foliage.

PAINTING INSTRUCTIONS
BIRDHOUSE POST
Doubleload a 1/2" angular brush with Ivory and Mocha Brown. Using the chisel edge of the brush, apply vertical strokes imitating wood grain. Add Dark Brown to the same brush and add a few darker veins. Let dry. Use the same brush to float Payne's Grey down the edges of the post and in the shadow area right below the birdhouse. With a #00 liner brush and Black, paint fine veins and cracks. Continuing with the #00 liner brush, add random veins with thinned Ivory, and then repeat with undiluted Ivory.

BIRDHOUSE
With a 1/2" angular brush and White, undercoat the board at the base of the house, and allow to dry. Use the same brush to paint the board with Bright Red, blending into Red Iron Oxide in some areas so the board does not look too uniform in color. Let dry, and then use #2 round synthetic brush with Black to paint the top of the board; use a #00 liner brush and Black to paint fine, horizontal veins.

Undercoat the roof with a 1/2" angular brush and White; allow to dry. Clean the brush, and then apply a coat of Phthalo Blue. Clean the brush again, and then doubleload with Dolphin Grey and White. Paint the paneled wall, using the chisel edge of the brush to apply vertical strokes imitating wood grain, and let dry.

Using a #4 liner brush and Dolphin Grey, paint a suggestion of division lines between the planks. Loosely define these shadowy lines by painting a broken Payne's Grey stroke down the center of each. Clean your brush and randomly float Burnt Sienna to form some cracks. Add vertical, broken lines with Dark Brown to add texture to the wood.

Paint the underside of the roof with Black. Float a shadow under the roof using a 1/2" angular brush and Payne's Grey. Use a #2 round synthetic brush to lighten some panels with thinned Soft Grey.

Paint the edge of the circular opening in the wall using a #2 flat brush and Dolphin Grey, blending into White. With a 1/2" angular brush, float Cape Cod Blue on the wall around the opening to define the shadow. Deepen some areas with Payne's Grey. Allow to dry.

FOLIAGE
Transfer foliage. The leaves behind the birdhouse are formed with two S-shaped strokes using a 3/8" angular brush and different values of green, allowing the surface to dry between layers. Paint the first layer of leaves with Kelly Green (medium value), and then

(Continued on Page 54)

The Visitor
Pages 50 & 52-54

The Visitor

Instructions on Pages 50 & 54

The Visitor

(Continued from Page 50)

use both Gamal Green and Black Green to add a second layer (dark values). Paint the uppermost leaves using a brush randomly doubleloaded with Sea Grass and Sandstone.

The large leaves below the house are painted with the same colors as the leaves behind the house, using a brush doubleloaded with a dark and a light value. When complete, wash a few with Golden Brown.

Using a #2 round synthetic brush, paint the smaller leaves in the foreground with the same colors, also painting a few leaves with Stonewedge Green and others with Old Parchment.

Use a #00 liner brush and Burnt Sienna to paint the twigs and veins in the leaves. Paint the bits of sky that show through the leaves (both above and below the birdhouse) with a #2 round synthetic brush and Glacier Blue. Use a #2 round synthetic brush and thinned Dark Brown to paint the shadows projected by the leaves.

CAT

Step 1: Use a #00 liner brush and White to paint hairs along all transferred lines, being careful not to cover the dark areas, and let dry. Using a #2 round bristle brush and Burnt Sienna, drybrush along these dark stripes to define the dark markings on the face of the cat. Also drybrush around the dark area in the center of the ears. Once dry, use a 1/2" angular brush to apply a Mocha Brown wash over the entire area.

Drybrush muzzle, chin, and around eyes with a #2 round bristle brush and White, applying a denser coat in the center of each area and fading towards the edges.

With the liner brush, reinforce the lighter areas by painting another layer of White hair. Once dry, apply a Golden Brown wash using the 1/2" angular brush, and let dry.

Use a #2 round bristle brush with Dark Goldenrod to drybrush a shadow on the leg, just below the face, and also over the central portion of the paw.

NOSE: Basecoat the nose using a #2 round synthetic brush and Pink Angel. Clean your brush and outline nose with Georgia Clay, leaving pink highlight areas in the center. Touch up the shape of the nostrils with Black.

Step 2: Paint hair using a #00 liner brush and Burnt Sienna, starting from the drybrushed Burnt Sienna areas defined in step 1 and pulling your strokes over the lighter areas. Also paint hair over the eyelids, between the eyes, around the outer edges of face, and to create a subtle suggestion of toes.

With the same brush, add some Black hair over the Burnt Sienna areas and a few on the left side of the leg. Clean your brush, and use White to reinforce light areas on the eyelids, and to shape the muzzle and chin.

MOUTH: Paint the mouth with a #2 round synthetic brush and Black. Let dry. Use a #2 round bristle brush and White to drybrush highlights over the lighter areas of the muzzle. With the same brush, paint thinned Golden Brown to form a faint shadow along the line of the mouth. After painting the whiskers (see below), add a few very fine hairs with White over the mouth, extending from the upper part of the muzzle.

EARS: With a #00 liner brush, add Burnt Sienna hair on the back side of the right ear and along the inner edge; also pull some hair from the darker areas and overlapping the lighter ones. Add a few Black hairs in the center.

EYES: Refer to the color worksheet to get an idea of how eyes are painted. Remember, however, that each animal's eyes are slightly different.

Step 1: Avoiding the black pupil area, undercoat irises with White using a #2 round synthetic brush, and let dry. Basecoat irises with Blue Jay using the same brush, and let dry once again.

Steps 2 and 3: With a #00 liner brush, add White and Phthalo Blue dots on the lower two-thirds of each iris. Use a liner brush and diluted White to outline the pupils. Once dry, use a 3/8" angular brush to apply a Phthalo Blue wash over the eyes, and allow to dry again.

Step 4: With the #00 liner brush, dabble a few flecks of very thin Mocha Brown here and there on the lower half of each iris. With the 3/8" angular brush, float White along the lower border of each iris, and allow to dry. Use the same brush to float Phthalo Blue along the upper border. Once dry, add a touch of color by painting small Blue Lagoon spots on the upper portion of the iris using a #00 liner brush.

Add the shines on the upper portion of the eyes and a small dot in the corner of each eye with the same brush and White.

WHISKERS: With a #00 liner brush and thinned White and Black, paint defined thin lines side by side (touching) for each whisker. This will give each individual hair both body and continuity as it crosses dark and light areas.

FINISHING

Refer to "Finishing" in the "General Instructions" at the front of the book.

Pattern on Pages 52-53

The Visitor

Where Are MY Jeans?!?!?

Color Photo on Back Cover

PALETTE
DELTA CERAMCOAT ACRYLICS
Antique Gold
Black
Black Green
Blue Velvet
Bright Red
Burnt Sienna
Cape Cod Blue
Copen Blue
Dark Brown
Dark Goldenrod
Dolphin Grey
Gamal Green
Georgia Clay
Glacier Blue
Golden Brown
Kelly Green
Light Foliage Green
Maple Sugar Tan
Mocha Brown
Payne's Grey
Phthalo Blue
Pink Angel
Quaker Grey
Sea Grass
Straw
Tangerine
Tide Pool Blue
Vibrant Green
Wedgwood Blue
White

SPECIAL SUPPLIES
MDF or Masonite album (approximately 12" x 16")
Old stiff angular brush (for stippling treetops)
Old scruffy flat brush (for stippling foliage on bushes)
Satin ribbon, 1/2" x 1 yard

PREPARATION
Please refer to "Surface Preparation" in the "General Instructions" section at the front of the book. Basecoat the front of the album with Black + sealer (1:1). Let dry. Paint cut edges with Mocha Brown.

INSIDE AND BACK: Basecoat the rest of the album with Ivory + sealer (1:1). Create wood grain on the inside and back of the album using the chisel edge of a 1/2" angular brush. Working wet-on-wet, apply random brushstrokes of White, Mocha Brown, and Burnt Sienna, working the colors slightly into each other, without over blending them.

PAINTING INSTRUCTIONS
BACKGROUND
Paint the green area of the background (above and behind the dog's body) before transferring the design, using a 1/2" angular brush and working wet-on-wet. Apply Gamal Green starting at the upper-left corner, then blend into Kelly Green towards the center, and fade into Light Foliage Green on the right. For the sunlit area on the right, blend Light Foliage Green into White. Let dry, and transfer the design.

TREES AND FOLIAGE
You may find it useful to refer to the small section on developing foliage on the "Breakfast" project color worksheet, figures 1 through 3, and to the front of the book.

TRUNKS: Begin by painting the tree trunks. Use the chisel edge of a #4 flat brush to apply vertical strokes of Mocha Brown and White. Blend colors unevenly into each other and define some knots in the wood. Let dry. Use a #2 round bristle brush with Quaker Grey to drybrush here and there over the largest tree trunk to enhance its rough appearance. On the left trees, use these same colors to paint the branches that show through the foliage. Using a #00 liner brush and Burnt Sienna, deepen the centers of the knots and paint fine veins down the trunks.

Paint branches on the tree on the right with a #00 liner brush and Black. Highlight with Burnt Sienna.

BACKGROUND TREES WITH GREEN FOLIAGE: Use an old, stiff-bristled angular brush to stipple the foliage. Define outlines with Black Green, always stippling with the tip pointed outwards to give the illusion of small leaves and twigs at the ends of the branches. Let dry. Clean the brush and stipple White in the center areas of the foliage. Once dry, stipple Dark Goldenrod over the white areas.

If necessary, touch up the background between the tree trunks with a #2 Ruby Satin flat brush and Light Foliage Green. Also add some touches to the background on both sides of the branches that show through the leaves.

FOREGROUND TREES WITH RED FOLIAGE: An old, stiff-bristled angular brush is used to stipple the foliage on the tree on the left; use the chisel edge of an old, scruffy, flat brush to stipple the trees on the right. Using Black Green, define outlines by stippling with the tip pointed outwards to give the illusion of small leaves and twigs. Let dry.

Clean your brush and stipple White in the center foliage areas. Stipple a touch of Dark Goldenrod on the tree on the right. Once dry, stipple Bright Red over the white areas and over the goldenrod areas of the right tree, allowing the goldenrod to show here and there.

With same brush, stipple Kelly Green grass and weeds at the base of the trees, this time pointing the tip of the brush upwards. Lightly stipple tiny White flowers on the grass and background tree above the dog.

BUSHES ON THE RIGHT: Use the chisel edge of an old, scruffy, flat brush to stipple the colors in layers, moving from dark to light shades, and working from outer tips towards the center. Allowing each layer to dry, start by softly stippling a layer of Black, and then stipple a layer of Black Green. Stipple a Georgia Clay layer, and then stipple the upper layer of the bush in the foreground with White. Let dry, and then use a 1/2" angular brush to apply a Dark Goldenrod wash over both bushes. Allow to dry.

Drybrush shadows at the base of the bushes with a #6 round bristle brush and Black. Paint the area under the dog and behind the paw on the right with a 1/2" angular brush and Vibrant Green. Lightly stipple bush colors in grass above dog's back and top paw.

WEEDS: Paint the weeds at the bottom of the album with a #4 liner brush. Load the brush with Sea Grass, touch the tip into

(Continued on Page 56)

Where Are MY Jeans?!?!?

(Continued from Page 55)

Maple Sugar Tan, and then pull loose strokes to define the weeds. With the same brush, paint the shadows on the bent weeds with diluted Mocha Brown. Highlight with Maple Sugar Tan using a #4 liner brush. Let dry, and then apply a Dark Goldenrod wash to some of the weeds using a 1/2" angular brush. Let dry. Drybrush shadows on the base of the weeds using a #6 round bristle brush with Black Green.

DOG

Please refer to the figures C1 and C2 of the color worksheet.

Figure C1: This dog is painted by first creating a color map. As illustrated on the color worksheet, painting generally begins by using the drybrush technique to apply basecoat colors, thus establishing a color map for light and dark zones. You may need to repeat this step to get the coverage you desire. To blend the color zones together, I generally load the brush with the darker color and blend where the colors meet, starting in the dark zone and overlapping the edge of the light zone. Sometimes I use a third color to blend where the two colors meet.

With a #2 round bristle brush and White, drybrush on the raised areas of the wrinkles on the face; around the outer edge and down the center of the ear; on the top of the head; on the white areas of the body, leg, elbow, and paws; on the edge of the hind leg; and on the muzzle and back of jaw. Use a #00 liner brush to apply White hair to the lower edge of the belly.

Use a #4 Ruby Satin flat brush to apply Golden Brown to the back of the head, blending into Straw towards the side of the forehead.

Use a #2 Ruby Satin flat brush with Maple Sugar Tan to paint the shadow areas of the wrinkles on the left side of face, blending with Mocha Brown as you move towards the bottom of each wrinkle. Deepen the shadows with Burnt Sienna. Paint the spot in the center of the muzzle in the same way, using the lighter color in the center.

Use a #2 round bristle brush and Golden Brown to drybrush the wrinkles under the mouth. Paint the mouth and tidy up the shape of the nose with Black, using a #2 round synthetic brush. With Golden Brown and same brush, paint the top of the muzzle, adding fine hairs overlapping the White areas.

Use a 1/2" angular brush to apply a Dark Goldenrod wash over all areas of the dog, except those areas that must remain white. Let dry.

With Georgia Clay and a #4 round bristle brush, drybrush the inner and outer edges of the border of the ear and around all of the shadow areas on the ear. Also drybrush the area above the upper eyelid and add touches of color in the darker areas of the wrinkles of the face. Drybrush along the shadow to the right of the ear, the dark spot above the ear, along the shoulder muscles, on the belly down to the hind leg, and around the dark shadow between the legs. Use the same brush and Tangerine to drybrush the hind leg, working from the center of the leg towards the edge, stopping just before reaching the edge.

Clean the brush, and drybrush Tide Pool Blue to shade the white area at the back of the jaw line and on the bend of the elbow. Use a #6 round bristle brush and Quaker Grey to drybrush over the lighter areas of the dog's back and rib areas.

(Continued on Page 58)

Where Are MY Jeans?!?!?

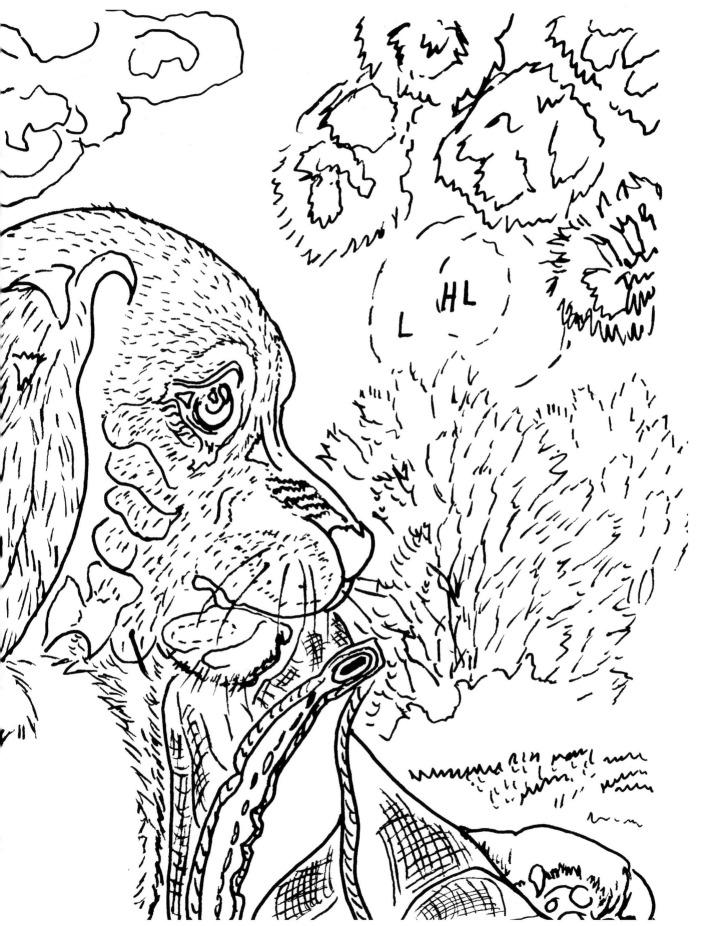

Match and attach with the pattern section on pages 58-59

Where Are MY Jeans?!?!?

(Continued from Page 56)

Figure C2: Use a #00 liner brush to paint Black hairs starting on the black areas and overlapping into the white areas.

Next, add shorter hairs on the face with White. Make the hair denser in the lighter areas of the muzzle, always starting your strokes in the white areas and overlapping the darker ones. Do the same for the area near the neck, as well as the legs, paws, and white spot on the back. Paint long whiskers.

Paint a sparse amount of short White hairs over the brownish areas of the head and ear, always following the direction of hair growth and allowing the brownish color to show through. Also paint a fine layer of White hair over the muscles above the elbow.

Add random Tangerine hairs over the black spot on the ear, above the eyelid, belly, hind leg, chest, muscle area above the elbow, and on the lighter areas of the dog's back and ribs.

As a last step, starting from the dark areas and pulling hairs over the lighter ones, add a few Black hairs to the following areas: in the central area of the ear; on the muscle area above the elbow; on the belly; front of chest; above nose; and sparsely on head and wrinkles.

PAWS: Paint the pads on the left paw with a #2 flat brush and Pink Angel, blending with Georgia Clay towards the edges. Paint nails with Pink Angel and the separations between toes with Payne's Grey. Pull soft White hairs and a few Black ones over the pads using a #00 liner brush.

Use a #2 round bristle brush and Mocha Brown to drybrush over the separations between toes of both paws. While you are working with this color, you may want to enhance the wrinkles on the elbow.

EYE: Paint the upper eyelid and loosely along the bottom eyelid with a #00 liner brush and Cape Cod Blue. Use a #2 round synthetic brush to paint the iris with Burnt Sienna and the small white area with White. Let dry.

Use the same brush and White to add a shine along the right side of the iris. Let dry, and then apply a Phthalo Blue wash with the same brush over the shine area. Let dry. With White, add highlights over the shine spot and another shine closer to the center of the eye.

Deepen the shadows around the eye and the small dark triangle on the bridge of the nose with the same brush and Dark Brown.

JEANS

Please refer to the "A Cozy Nook" project for instructions on painting these jeans, without drybrushing with Straw. Paint the stitches for these jeans with Glacier Blue.

FINISHING

Refer to "Finishing" in the "General Instructions" section at the front of the book.